MASTER GUIDE FOR
PHOTOGRAPHING
HIGH SCHOOL SENIORS

Dave Wacker

Jean Wacker

J. D. Wacker

AMHERST MEDIA, INC. ■ BUFFALO, NY

In Appreciation

Although we as a family have provided the words and images for this book, it would not have been possible without help from our team members. We wish to thank Molly for hours of typing this manuscript and revising it many times. We also want to thank Shelley for spending hours searching for picture files and preparing them for use in the final book.

Published by:
Amherst Media, Inc.
P.O. Box 586
Buffalo, N.Y. 14226
Fax: 716-874-4508
www.AmherstMedia.com

Publisher: Craig Alesse
Senior Editor/Production Manager: Michelle Perkins
Assistant Editor: Barbara A. Lynch-Johnt
Editorial Assistance from: John S. Loder, Charles Schweizer

ISBN-13: 978-1-58428-252-5
Library of Congress Control Number: 2008942238
Printed in Korea.
10 9 8 7 6 5 4 3 2 1

Table of Contents

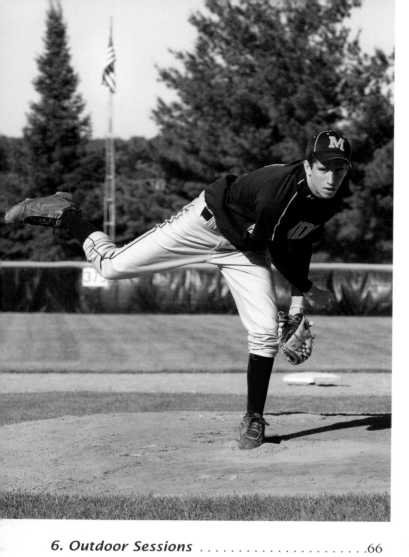

About the Authors

The Wacker family's lives have been entwined with the photographic profession for over one hundred years. In the 1920s, Frank Wacker was actively working in public electrical utilities while studying to be an electrical engineer and used the additional income from doing family portraits to pay for his education. Frank's son David, one of the co-authors of this book, was born at the beginning of World War II and soon became an assistant in his father's photographic business, planting the seeds of a future career.

Although Frank discouraged Dave from going into photography, in favor of being a minister or teacher, the love of photography grew and by the time Dave was in high school he was a photographer for the school newspaper, the yearbook, and the community's weekly newspaper. Naturally, when freshman orientation rolled around, Dave was there with his camera to cover the event—after all, it was a great chance to evaluate the incoming freshman girls and be the first to meet the best of the group. Dave spotted a pretty blonde with long flowing hair and immediately picked out his front page model. This is how he met Jean Ann, his future wife (and another of this book's coauthors).

It just so happens that Jean's grandfather, Andrew, was also a photographer with a picture-postcard business established in 1906. Andrew was an accomplished artist, painter, and cabinet maker as well as photographer. Some of his work now resides in the Smithsonian Museum and an inlaid table is part of the White House furniture. Apparently, Andrew's talents were passed directly on to Jean Ann. She excelled in art class and had an interest in photography. Therefore, two families rich in photographic skills were united when Dave and Jean Ann were married in 1962.

The next generation brought John David (J.D.) to the scene. J.D. (the third coauthor of this book) is said to have been born with a camera in his hands. At three, he was taking pictures with his Kodak camera. A five, he could develop his own film and make proof sheets of the pictures he took. He even made a yearbook for his kindergarten class. In high school, J.D. worked part time for a county newspaper, where he entered and won an Associated Press competition. This success spurred him on to joining the Professional Photogra-

(Left to right) J.D., Jean, and Dave Wacker.

phers of America (PPA). This association allowed him the opportunity to compete with professional photographers and earn a Master of Photography degree at the age of 21, the youngest age at which anyone has ever completed this degree. The following year, he received a BS in business and achieved the PPA Craftsman degree. He has since added the Master of Electronic Imaging degree to his list, along with hundreds of photographic awards. He has won many Kodak Gallery Awards and the top photographic award in the profession: the Kodak Gallery Elite Grand Award.

J.D. has led the industry in the development of grassroots usage of digital photography. Aided by his understanding of computers and the ability to speak to groups, he has become a sought-after instructor and speaker. He currently has a popular photographic book, published by Amherst Media, titled *Master Posing Guide for Portrait Photographers* on the market.

Dave, Jean, and J.D. Wacker have spoken to groups in forty-two states and five countries. Rather than being singled out as individuals they are referred to as "The Family." Together, the Wacker family covers the entire gamut of professional photography, from image capture to marketing and sales. They have also co-authored a self-published digital help book called *The Wackers' Digital Cookbook*, which is now in its

fifth printing. Their easy-to-follow teaching style makes even the toughest theories and demonstrations easy to understand. They pride themselves on presenting material in a no-nonsense, nuts-and-bolts, how-to-do-it way. While always being on the cutting edge of new technology, they never forget the new photographers who are starting their businesses. The Wackers are committed to helping photographers get their lives back and start making more money right away.

Individual Biographies

Dave Wacker *(PPA Certified, M.Photog., Cr., IE API, F-WPPA, HF-PPH, F-IPPA)*. Dave, a PPA National Award recipient, affiliated juror, approved photographic imaging instructor, and Kodak Mentor, has received numerous Kodak Gallery awards, Epcot selections, Fuji Masterpiece awards, the PPA Imaging Excellence Medal (2004), WPPA (Wisconsin PPA) Courts of Honor and Best of Shows, and twenty-eight PPA Loan print awards. He was WPPA's Combined Categories Photographer of the Year in 2004 and 1995, and Indianhead PPA's Photographer of the Year five times. In 2002, all four of his print entries were selected for the PPA Loan Collection and for the ASP Top 100 Traveling Loan Collection. He has had images and articles published in *The Professional Photographer, Lens, InFoto,* and *Rangefinder* magazines, specializing in the development of a PhotoPark, the Mobile Cloud, and marketing and management techniques. Dave also holds a BS in chemistry and mathematics and an MS from the University of Idaho in biology and animal behavior. He has done postgraduate work at the University of Wisconsin, the University of Colorado, and Temple Buell University. He has authored several books and is a contributor to Time Life Publishing.

Jean Wacker *(PPA Certified, M.Photog. M.Artist M.EI Cr., IE API, Ph.A.L., F-WPPA, HF-PPH, F-IPPA)*. Jean, a PPA National Award recipient, affiliated juror, approved photographic imaging instructor, and Kodak Mentor, was the fourth in PPA history to receive all four PPA degrees. She was the PPA Color Artist of the Year in 1990 and has received numerous PPA Loan print awards (including one scoring a perfect 100 in affiliated competition). In 2006, she had the highest scoring image, earning a 99 in the American Photographic Artisans Guild competition (APAG). In 2004, Jean received the PPA Imaging Excellence Medal. From WPPA, she received four Best of Show awards and has been named Combined Categories Photographer of the Year (1993), Artist of the Year (1991 and 1992), Freestyle Artist of the Year (1991), and Color Enhancement Artist of the Year

(1990 and 1991).She has also earned numerous Kodak Gallery Selections. Recently, Jean developed "Jean's Digital Makeup Kit™," an Adobe Photoshop software supplement and technique that aids portrait photographers and photographic artists in making the transition from traditional to digital retouching and enhancement.

J.D. Wacker *(PPA Certified, M.Photog. M.EI Cr., IE., API, F-WPPA, F-IPPA)*. J.D. is a PPA affiliated juror, approved photographic imaging instructor, and a Kodak Mentor. In 2008, J.D. was awarded Senior Photography International Gold Medal of Achievement. In 2007, he was awarded the PPA Imaging Excellence Award Medal and received the highest total score in Class A from the Senior Photographers International, including the highest scoring creative folio overall. He is the 2006–2007 WPPA Senior Photographer of the Year and recipient of the Highest Scoring Female Folio Award. In 2006, J.D. was recognized as the producer of "The Best Web Site" for www.photobyjd.com. He took first place in both the male and female folios in Class A and was awarded the Senior Choice award by SPI in 2005. He was the 2004–2005 and 2003–2004 WPPA Senior Photographer of the Year and recipient of the Senior Folios Photographers' Choice Awards and People's Choice Awards for both of the male and female categories. Also, he was the 2001–2002 WPPA Senior Photographer of the Year and recipient of the Senior Folios Photographers' Choice Award. He received the ASP Regional Gold Medallion Award (Wisconsin) in 2002. In 1999, J.D. received the Kodak Gallery Elite Grand Award, the PPA Sports and Events Best of Show Award, and the Indianhead PPA Photographer of the Decade Award. He received Kodak's Gallery Award seven times, Fuji's Masterpiece Award six times, and WPPA's Best of Show Award four times. He is a member of Kodak's Digital Focus Group and the Adobe Advisory Panel. Besides his photographic degrees, he also holds a BS in business administration with an emphasis in marketing. He is a contributing writer for the *Professional Photographer* magazine. He has also had images and articles published in Eastman Kodak's *The Portrait,* as well as *Lens* and *InFoto* magazines. His book, *The Master Posing Guide for Professional Portrait Photographers,* a best-seller among photography books, is available from Amherst Media.

Contact

To learn more about the Wackers' imaging workshops, classes, and educational materials, please visit www.photobyjd.com.

Introduction

Why does the world need another book about photographing seniors? When we were looking for information to improve our business, we reviewed many books on senior photography, some were outdated, some only bragged about the author's skills, some showed very low quality images, some lacked any knowledge of digital techniques, and others ignored the need for marketing. None of the books were really very helpful.

Staying Ahead of the Curve

As a photographic family that has been in business since 1906 and actively photographing high school seniors since 1962, we realized we had many things to share with both new and experienced high school senior photographers.

With each change in technology has come a change in how we must approach senior photography.

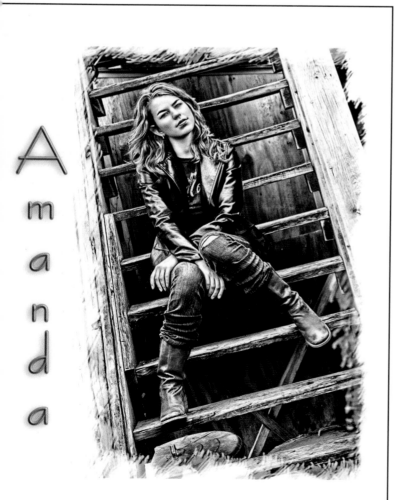

In particular, our family began photographing high school seniors outdoors well before other studios ventured away from the camera room. Our construction of a photography park next to the studio in the 1960s was among the first such endeavors. With the introduction of a 6x12-foot mobile diffuser (see page 74), we have gained the ability to photograph seniors outdoors all day—not just in the mornings and late afternoons. Additionally, in the early 1990s we were involved with Kodak in the development of digital cameras and the creation of a workflow that *saved* time rather than demanding *extra* time in front of the computer. By 1998, we were among the first professional studios to be 100 percent digital.

Looking back over a century in photography, it's clear that our business has succeeded because of its ability to stay on the cutting edge. With each change in technology has come a change in how we must approach senior photography. No longer is one photographer in each town the only studio to which all students go for their portraits. No longer is the student satisfied with a series of head-and-shoulder images dressed in their Sunday best.

New Challenges

In the 1980s and 1990s, students still wanted an image for their yearbook. This was usually combined with assorted indoor and outdoor poses. Multiple clothes changes and poses with a variety of props were assumed. This was the golden era of high school senior portraits for the studio photographer. Profits were great and, soon, studios became dependent on the senior market for the majority of their annual gross.

However, lured by profit, many advanced amateurs sought to become "professionals" by moonlighting as senior photographers. (Notably, photography remains one of the few industries in which people can call themselves "professionals" with no proof of competency, certification, or licensing.) With the introduction of inexpensive digital cameras and computers, every wannabe photographer leapt into digital photography. Seemingly, everyone had

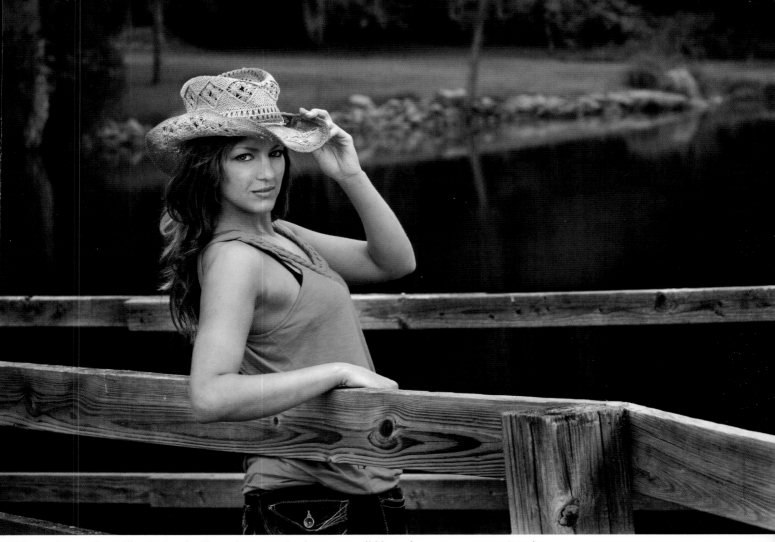

The senior market still exists and will continue to exist, but not at all like we've come to expect it to be.

an uncle or friend who could do their photographs—and a nearby WalMart to print the images for pennies. Soccer moms, high-school camera enthusiasts, and camera-club members all became "high school senior photographers." Teens have even organized picture-taking get-togethers, where they take each others' senior portraits and post them on web pages for all their friends. They don't even require a digital camera—a cell-phone camera will do. In some areas, it's become cool *not* to have a picture in the year-book and to be represented by a blank space with "no photo available" written across it.

Have we gotten your attention? The senior market still exists and will continue to exist, but not at all like we've come to expect it to be.

What's a Photographer to Do?

There are some seniors who will not come to you for por-traits. This has always been true. The answer is to recruit those seniors who do still want senior images. It is up to you to create this desire! Seniors have more money to spend than ever before. As a result, it is no longer the par-ents who choose where the child goes for his/her portraits. It's all about them! They have the control.

Determine What Seniors Want. Senior portraiture is a "want" business. Nowadays, almost anyone can service photography "needs" (like a driver's license photo). As a professional photographer, you have to market what the present-day senior *wants*—whatever they think is "cool."

What this means will change regularly. It's your job to make an educated guess about what is going to be cool for this year's senior class. Study their magazines, television shows, and what they say on MySpace and Facebook. Then create something that is "new and cool."

If you can do this—year after year—and provide con-sistent, professional-quality images, you'll have all the senior-portrait business you can handle. (Plus, a resurgence

FACING PAGE—*Providing indivualized images is a key to success. Doing this means spending some time really getting to know your subject.*

of traditional values is bringing emphasis back to family and quality portraiture.)

Provide an Individualized Experience. Once you've gotten the senior to book their session, be ready to give them a variety of activities and poses. Spend some time to really find out what is *their* "cool." This can be done using a questionnaire, a pre-session consultation, etc.

Everyone will want something that is completely different and made just for them, but don't be surprised if you hear one of them say something confusing like, "I want something different—just like my friend had." There are no definite answers that will satisfy high school seniors, just try to have enough variety to hit on what they want—even if they don't really know what that is. When you hit what they feel is cool, they'll let you know immediately. This is your clue. If you're smart, you'll follow whatever the theme may be for the remainder of the session.

Build Enthusiasm for a Big Sale. When you have captured the poses that please them most, it's time to plant the seeds of profit. On the digital screen, show them images that make them look great and reflect their individuality. Present samples of products that are available for the presentation of their images. Now is the time to suggest add-ons like books, banners, frames, composites, etc. We'll spend an entire section later in the book (see chapter 2) discussing the numerous ways to build an average order into a profitable one.

Perfect and Enhance Your Images. One more factor that will keep the true professional creating senior portraits is the enhancement that is done after the image is created. With Photoshop being taught in high school photo classes and at scrapbooking meetings, knowledge of what *can* be done is widespread. Therefore, the clients expect perfection in their portraits retouching—and may even demand head swaps from one image to another. However, just because the client knows it can be done doesn't mean the client can do it with the same expertise as the professional photographic artist. After all, we all know about the game of golf, and we could all use the same ball and club as Tiger Woods, but the results would be quite different when it comes to where that ball would land. With increased knowledge comes appreciation. Your clients will appreciate (and pay for) your commitment to quality.

Offering a variety of unique products can help get seniors excited about their session.

Accordingly, a large portion of this book will describe Photoshop techniques in a simplified manner that will improve each image you present your client. However, learning to produce a product that is superior to what your competitors may be delivering is something that requires time, talent, and practice.

Additional Refinements

Aside from the aforementioned aspects of succeeding as a senior-portrait photographer, this book will also address

some additional areas where finessing your practices can improve your images and streamline your business.

Better Shooting Techniques. Throughout this book, you'll see examples of different poses, situations, and activities. These are presented to give the reader ideas on how to begin photographing high school seniors. You'll see examples of our most popular senior-portrait poses (for

Please join us as we celebrate Alyssa's graduation from Greenfield High School

Saturday, June 10th, 2009
3:00 pm

The Smith Home
4242 S. 89th Street
Greenfield, WI

R.S.V.P. by June 7th
414-545-1270

Not every product will be right for every client, so offering variety of choices is critical.

guys, girls, and couples), a variety of popular backgrounds and props, and setups for getting great results outdoors.

An Efficient Workflow. Another section will suggest a daily workflow and describe the equipment that has proven most useful in our studio. With digital, there are many paths that lead to the same product. Ours is by no means the only way, but it's the the best for us and we've found that it takes the fewest steps. Even if a method produces a great product, if it's not efficient (in both time and materials) it will not be profitable. When time is not important, it's called a hobby; when profit is the goal, it becomes a business.

The Psychology of Marketing. In this day and age, getting the high school senior to choose your studio is the one variable that you cannot guarantee. Therefore, chapter 1 covers the psychology of getting seniors to the studio, working with them in the camera room, and maximizing the sales session. Incorporated in these sections are some all-important marketing techniques for reaching high school seniors. Examples of promotions that have and have *not* been successful for us are described. (We talk about the unsuccessful programs because regional tastes and senior styles vary so much you may still wish to try them in your area—or you can learn from our mistakes.) Included in all marketing programs is a need to evaluate the results of each effort, so our tracking methods are given whenever applicable.

In Closing

Whether it be the pictorial examples, the marketing, the Photoshop tricks, the time-saving workflow, or the camera techniques, we hope this book will lead you to a successful high school photography endeavor.

1. Getting Seniors to Your Studio

Third graders are now taught keyboarding. Kindergarten pupils are playing games on laptop computers. By middle school, students have their special e-mail pals. High school students are researching on the web and even have their own web sites. They can download research papers and scan images. These are your future clients.

Don't be surprised when they bring in your scanned proofs with the retouching they did in the school Photoshop lab. You may be able to fool the parents, but don't try to play computer expert or digital imaging specialist with them. You'll lose. This tech-savvy generation must be approached differently and marketed to differently than their parents. The parents will be impressed if the image matches their perception of their perfect child, complete with a shirt and tie for grandma's gift picture. The student, on the other hand, knows how much more can be done—and has an idea how to do it.

Demonstrate Your Skill

Fortunately, those who have tried to do it themselves know that success requires a high level of skill and an expensive collection of hardware and software. We've all appreciated watching superstars like Michael Jordan and Tiger Woods make difficult shots look easy. But for those of us who have tried, even using the same equipment, we seldom have the same success.

Practice and Experience Pay Off. The same is true for all image-making skills: along with retouching, lighting and posing are skills that are perfected only through practice and experience. Show these young people examples of your skilled work and they will choose your studio over your competition. After all, they all have egos and they want to look their best. If they know you have more skill in crafting flattering images, they will pay more to get your services.

It's Simple: Make Them Look Great. Although it may seem fundamental, simply making your senior clients look their very best using professional posing and lighting techniques can set you apart. Unfortunately, many "new"

professionals have overlooked these skills in favor of learning more special effects. Conversely, many "old" professionals' basic portraiture skills have become rusty in their struggle to keep up with trends and/or make the transition to digital. Only by gaining a mastery of the *entire* process can you be sure that your image quality will be superior to that of your competition.

Prove Your Worth in Competition. Advertise how you are different from your competition and back it up with some samples. Give proof of your expertise by winning in photographic competition. No teenager will choose to wear sportswear of a losing team or poor player. It's no different when it comes to choosing their photographer. The affluent teen will always choose the winner, not the cheapest.

Appeal to Their Tastes and Egos

No matter how many awards you have won or how attractive your studio may be, seniors will only choose you if they want to. The senior will go to whatever place seems cool and is most likely to make them look good. Trying to guess exactly what is "cool" for this year's senior is impossible; it changes more often than our Wisconsin weather. You can, however, make some good educated guesses by keeping an eye on teen-oriented advertising in magazines, watching teen television programs, and browsing online social networks like MySpace and Facebook.

Target Marketing to High School Seniors

How best to get your message to the high school seniors will vary according to your individual situation. Urban studios must promote themselves to their clientele differently than rural studios, for example. The California market is different than the Midwest. Large cities will have different standards than small towns.

Evaluate Your Demographics. Your first step in selecting the right direction for your marketing efforts is to determine your demographics. To find your demographics, answer the following questions:

1. What are the basic characteristics of your high school senior market?
2. Are you considered urban or rural?
3. Are your students' backgrounds white collar or blue collar?
4. What is the income level—high, low, or middle class?
5. Where do the seniors get their information—Internet, television, radio, newspapers, magazines, malls, clubs?
6. What types of things do the seniors do in non-school time—hang out with friends, go to the mall, spend their time at home, work?
7. Are there local styles of clothing? Who sets the style?
8. What's their favorite music? Radio station?
9. Are the students' senior portraits controlled by contracts that dictate where they must have their yearbook portrait taken?
10. Who photographs the extracurricular pictures, like proms, dances, sports, and other activities?
11. Are there photography classes or clubs at which you can volunteer to give talks?
12. What type of photography—different from that offered by your competitors—can you offer that would be attractive to the local market?

By honestly answering these questions you'll get a feeling of what direction you should point your senior marketing program.

Get Feedback from Your Clients. To get feedback from our seniors, since 1990 we have given them a follow-up questionnaire. It all started when we wanted to know how important friends were in choosing a particular photographer for their senior portraits. To encourage participation, we offer a scholarship drawing for those who reply. The following is a copy of the questionnaire:

Instructions: Please rate the following on a scale of 1 to 5, with 5 being *very* important and 1 being *not* important.

1. The distance you had to travel to the studio.
2. The studio's reputation of quality photography.
3. The free offer of wallets, t-shirts, bumper stickers, etc.
4. The influence of friends.
5. The price of portraits.
6. Availability of indoor and outdoor sessions.
7. Variety of sets and backgrounds.
8. Personality and friendliness of the staff.
9. Awards the staff has won nationally and internationally as well as the photographic degrees earned.
10. Receiving free sittings or images.

To our surprise, the influence of friends has never been among the top reasons for choosing our studio (as you can see in the chart below, which shows the survey results). Year after year, the first reasons have not varied—and, in fact, the overall ratings have stayed pretty much constant. The importance of price has moved up from sixth to fourth the past couple of years. Clearly, the importance of your studio's reputation for quality and the friendliness of

	1991	1996	1997	1999	2000	2001	2002	2004	2005	2006	2007	2008
1	2	2	2	2	2	2	2	2	2	2	2	2
2	7	8	8	8	8	8	8	8	8	8	8	8
3	8	7	7	7	7	7	7	7	5	6	6	5
4	6	5	5	5	6	5	6	5	7	5	5	7
5	5	6	6	6	5	5	6	6	6	7	7	6
6	9	9	9	4	9	9	9	4	9	4	4	9
7	10	1	4	10	1	1	4	9	4	9	9	10
8	4	4	10	9	10	10	1	1	1	3	10	4
9	3	10	1	3	4	4	3	10	10	10	3	1
10	1	3	3	1	3	3	10	3	3	1	1	3

Students were asked to rank the importance of twelve factors on their selection of the studio (these appear above and are referenced by number in the left column of this chart). This chart reflects ten years of responses, ranking these factors from 1 (most important) to 10 (least important) for each year.

your staff cannot be overemphasized. (We should also note that adding a separate comment box on the questionnaire has been our best source of testimonials—and with a scholarship prize at stake, most respondents seem to feel that writing a glorious essay will help their chances of winning!)

Direct Mail

For most marketing plans, a sound direct-mail program is a necessity. Word of mouth is the best of all marketing, but direct mail is the best place to begin and word-of-mouth will follow. Direct mail is more important for rural areas than urban. However, even in urban areas where mall displays are a proven way to get attention, direct mail is an effective call to action and a powerful follow-up.

Direct-mail pieces should be designed to quickly grab the recipient's attention.

Designing Your Mailers. A quality direct-mail piece will be a major part of your advertising budget. If you're new to the field, plan on devoting at least 10 percent of your budget to direct mail. For established studios, you can budget 6 percent (or less) for direct mail. Keep in mind that, to be most effective, your direct-mail piece must get the high school senior's attention. Here's that "cool" thing again. The following are some things to remember:

1. *Show Your Best Images.* Featuring an attractive girl or boy is a good place to start—but don't try to show every senior you photographed last year. Focus on the best examples of your work.

2. *Minimize Text.* Seniors look but read only when necessary. Get their attention with knock-out images—use color, black & white, and images with special art techniques. We feature lots of pictures but only a few powerful words. These are designed to appeal to seniors, with themes like, "Who am I?" or "Who do I want to be?"

3. *Include a Call to Action.* A call to action is critical—it's what gives recipients a reason to call immediately. For example, you could offer an attractive discount on wallet-size prints if they respond before a certain date.

4. *Don't Forget the Critical Information.* Include your studio name, telephone number, and web site address in a prominent spot. Also, don't make the mistake of thinking that everyone knows where you are located. We see many examples of postcards for studios that do high-school senior photography. They all boast about being the best, but they often make the mistake of giving their studio's name *without* listing their address or city. You'd be surprised how many studios have names that sound quite similar (like Design, Countryside, Modern, In Photo, etc.) and this can cause a great deal of confusion.

Consider Outsourcing the Design and Production. If making a direct-mail piece seems too overwhelming, may we suggest Blossom Publishing Co. (www.Blossom-Publishing.com). We have used a variety of excellent publishing companies, but Blossom is the complete package. We used to spend a considerable amount of time putting together our annual direct-mail pieces, which include a sixteen-page magazine, a twelve-page digest, and numerous postcards. At Blossom, we give them our ideas, what we want to say, the style we like, and our image files—and they do the rest. They have different price levels depend-

In your marketing pieces, keep the text to a minimum and focus on great images.

ing on how much we want to do ourselves (or have time to do). They e-mail us a proof, followed by a hard copy, and even ship the final printing to us at no cost. (Unlike other companies we've work with, that would have a low price for printing, then charge for layout, adding borders, proofing, type styles, shipping, etc.)

Develop a Direct-Mail Marketing Program. Our marketing program begins with display ads in the local shoppers' weekly newspaper. These are great attention-getters and create word-of-mouth before the senior season begins. These ads are followed by 6x9-inch postcards featuring full color, "in style" portraits of seniors having fun or showing attitude on one side. On the reverse side, in black & white, text offers a reward for early booking or a special sale on portrait packages.

After the postcard is delivered in the mail, we send out a full-color, sixteen-page magazine filled with enticing photographs and information about what to expect, what to wear, the types of sessions offered, and the special enhancements and add-ons (books, frames, banners, etc.) that are available. This repetition keeps us fresh in students' minds, so when they are ready to book their senior-portrait session, our number is close at hand!

Include Prices. By all means, include prices on your direct-mail pieces; they are the best way to screen your clients. If you don't list your prices, the senior will think it means they can bring ten changes of clothing, spend all day, get free previews, and have no obligation to spend any money. Additionally, if you don't give prices, the senior's

parent may be suspicious of what it is going to cost and not realize that great photography may be well within their budget. In our area, photographers tend to keep their prices hidden until the senior is booked; we believe that this action by our competitors has brought us more clients than listing our prices has ever discouraged.

Make it Personal. The more personal you make your direct mail, the more effective it will be. After sending a mass mailing to the general high school senior population, we found the booking response rate was 14 percent. We then did a much smaller mailing to seniors—and did it in a different way: we hand wrote short personal notes to a hundred seniors. On this mailing, we had almost a 40 percent booking response! Lesson learned? In slow times, have the staff write personal notes to prospects instead of sending large quantities of more generic direct-mail pieces. You'll be amazed how valuable a sheet of paper can be.

Marketing Promotions to Try

Over the years, we have developed a variety of marketing schemes and promotions. For us, some were very successful. Others . . . not so much. Every marketing area is different, though, so just because a promotion either worked or didn't work for us doesn't mean you'll have the same results. Track your results on every promotion and decide whether to repeat it next year. Some promotions start slowly and take two years to fully reach their potential. If you see any gains in the first year, it usually means that the program has potential and is worth giving a second try.

With the declining number of high school seniors and the increasing number of photographers competing for this market, your marketing program must appeal to *all* high school seniors. This can be complicated, because what high school seniors desire in their graduation sessions varies with geographical, cultural, and social status. As a result, no single marketing approach can be expected to fully satisfy everyone. At our studio, we have designed a multi-level, year-round marketing plan with different approaches to urban, suburban, and rural demographics. We try to be ever-present—either in person, in the news, via direct mail, or on the web—the year round. When it's time for graduation portraits, this ensures that seniors will think of us first. The following are some of the seasonal and on-going senior promotions our studio had utilized.

$1000 Shopping Spree. This promotion was designed to increase senior session numbers and traffic. It was

Include Reorder Forms
In all orders we deliver, we include a reorder form. This makes it very simple to reorder when the senior discovers he/she needs more photographs. This procedure has brought in thousands of dollars in follow-up orders. One photographer who tried our suggestion wrote us a thank-you note and reported that, using this technique, he took in over $30,000 in three months without doing any extra camera work.

prompted by competitors who offered promotions with a car or shopping spree as the grand prize. In our contest, the students could earn one chance just by stopping in at the studio. They earned two chances for booking early, one additional chance for every $200 of order placed, and five chances for each senior they referred who booked a session. The students were thus encouraged to earn as many chances as possible to better their odds of winning.

Results. The results were poor. This promotion did not generate sufficient traffic or word-of-mouth to justify the investment. Compared to the big prizes they are used to seeing on television, students didn't think that a $1000 prize was worth getting excited about.

Co-op Marketing. Stores that high school clients frequent were given a display and a television with a looped video message. The store also distributed coupons for sittings at our studio and additional wallets. In exchange, we gave our clients discount cards for anything purchased at the clothing store.

Results. The results were poor, probably because we could not get into large mall stores and the local stores did not have the traffic that the large malls had. After its ini-

tial opening, the display quickly became old to customers of the stores and to the employees. This promotion, as planned, was not worth time and investment. However, the video message was later used for other promotions, so this was a secondary benefit.

Thank-You Ads. We started a series of ads that read, "Thank you for helping us win another Best of Show." Each time we won a Best of Show ribbon in print competition, we invited the subject to the studio for a photo with the print and ribbon. This image was used in the ad, and the subject was then given the ribbon. For big wins, the subject was even taken out to dinner afterward.

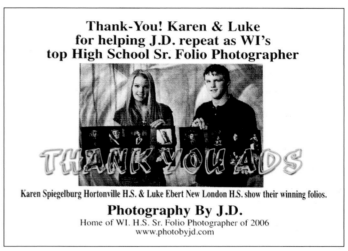

An example of our thank-you ads.

Results. The results were good because of the word-of-mouth that resulted. The subject would take the ribbon to school, work, church, etc., and tell everyone about the whole event and how nice the studio was to do this. Many referrals resulted from the promotions; some people even came in asking, "Can you make a ribbon winner with us?"

Find the Gold. In surveys, students tell us the number-one reason for choosing us over other studios is the colorful and informative brochures we send out in our direct-mail campaign. These responses, however, were from seniors who were not previously acquainted with our studio. What about those who were acquainted, though? Did they still read the direct-mail pieces? We started our "Find the Gold" game to test how effective our marketing was. Anyone finding our gold, hand-stamped logo on a direct-mail piece (placed on a small number of the mailers) had ten days to bring it to the studio for a crisp $50 bill.

Results. The results were fair. We had three returns from the first mailing, which is rather disheartening when you

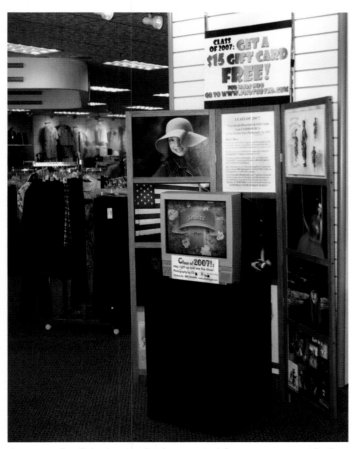

An example of the image display created for our co-op marketing.

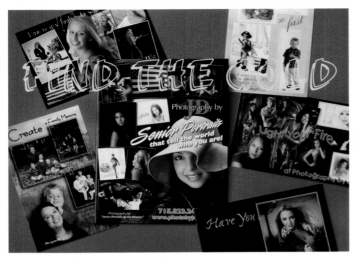

A flier with our "Find the Gold" stamp.

An example of the web puzzle game.

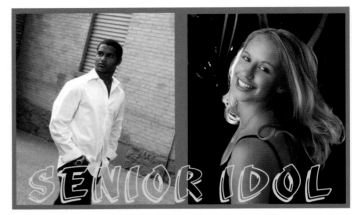

Our Senior Idol competition has produced overwhelming results.

consider the cost of producing each piece. However, when the first mailing's lucky winners were shown in our newspapers ads with their $50 prize, the subsequent mailings were thoroughly scrutinized—at least by moms. As a result, a higher percentage of them were returned.

The Web Puzzle Game. The object of this game was to be the first to identify the subject of a jigsaw puzzle that was partly completed. The puzzle was placed on the web site, and each day a piece was added until a winner identified the subject. Subjects varied according to the current promotions (children, high school seniors, families, etc.).

Results. The results were good. The game increased web site activity and was good investment with little expense. It was, however, a challenge to change the web site daily.

High School Senior Idol. The promotion was aimed at that group of high school seniors who always want to be models—or at least be treated like them. With the rage of the Idol shows on television, it was a natural combination. The rules were:

1. You must be photographed by Photography by J.D. by a specific date.
2. At your session, you would be evaluated by the staff on the following criteria:
 a. Personality
 b. Posing ability
 c. Photogenic appeal
 d. Poise
 e. Personal style

From these criteria the staff would pick the finalists.

3. The pictures from the finalists' orders were then placed on the web. Photographic judges scored each finalist based on the images on the web and each chose the first through fifth places. This accounted for half the final score. The public also voted via e-mail for their favorite. The judges' and public's scores were combined to determine the overall winners.

The winners, one male and one female, each received a $250 modeling contract and a large composite of their images. Runners-up each received a smaller composites of their images.

Results. The results were overwhelming! The response was so great it jammed the e-mail account and the volume of web-site hits went up 1408 percent. Requests were even made for a similar program for the next year. This was a great return on our investment as it hit the targeted mar-

ket directly. The promotion brought in the seniors we wanted—kids who were easy to work with, placed good orders, and created word-of-mouth throughout the area and beyond. We also used the event, and associated web pages, to introduce new product lines this year.

Scholarships. We started this program years ago and can now boast of giving thousands of dollars to deserving young people. Every student who fills out a scholarship application at the studio is eligible to win a studio-sponsored $250, $350, or $500 annual scholarship. Using cooperative marketing with other national groups, we also provide them with the opportunity to win a $5000 scholarship and $20,000 in cash (or a car). Our studio scholarships are presented by a member of the studio staff at an all-school function, like the spring awards day or at graduation exercises.

Our scholarship program is explained on our web site.

Results. The results have been very good, creating much goodwill and direct interaction with the upcoming group of students. Parents appreciate our concern to reward needy and deserving students. They encourage their students to come to our studio and take the opportunity to apply for the scholarship. Because of this promotion, the students we see are well above average in ability and personal commitment—and higher-than-average orders are placed. Of all our marketing promotions, this is the one most duplicated by other studios since 1985.

Coupons. Want your message to be noticed? Put it in the "P.S." section of your letter or put it on a coupon. We learned to include coupons the hard way. We've all experienced the annoyance of standing in line waiting for a woman to find her $.05 off coupon for a box of cereal, so

for years we didn't include any coupons. We also thought they cheapened our product. After all, you don't go to a Corvette dealer with a handful of coupons in hand. Eventually, however, we listened to our female staff members, who all wanted coupons to be part of our marketing promotions. We tried a few the first year, creating coupons that offered a percentage off something the customer was buying, never giving something away for free.

Examples of our coupons.

Results. The results have been very good. We've seen an increase in our bottom line and now include coupons in every senior mailing. A secondary bonus of using coupons has been our ability to track the results of certain marketing promotions. Using different coupon colors, different code numbers, or requests for a certain salesperson, we know which areas are using our coupons and which coupons are most effective. With today's high cost of advertising, tracking each marketing promotion is essential.

Lump in the Envelope. When you get your mail and sort through the pieces, how many pieces of junk mail do you not even open? Lots of them, right? But did you ever just throw away (or not open) one with a movable lump inside? Not likely. This ploy exploits people's natural curiosity. We've used bookmarks, keychains, plastic paper clips, pencils, notecards, etc. We even know of one poor photographer who put a piece of pea gravel inside!

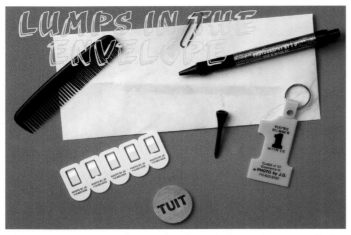

Who can resist an envelope with a lump in it—you're compelled to figure out what's inside!

Results. The results have been good. Not convinced? All I can say is try it. It works.

Your Web Site

When you construct your web site, be sure to include features that bring high school seniors to it on a regular basis. By adding activities like games, puzzles, and contests you can create a site that is interactive. One of our most successful draws has been a "game of the week" showcasing local high school activities. Seniors like to see themselves in action, whether it be in a game, in the parade, or at the dance. Once the students are in the habit of checking the web site to see if they are shown, we insert information about senior specials and new product lines. High school seniors seek out people they know to buy senior portraits and this is a great way to get them to know you.

Slide Shows for Social Networking Sites

The latest trend is having one's own web spot on a social networking site like MySpace or Facebook. To build on this, we design multimedia image galleries that utilize the senior's images to create a short video, complete with music. We give the show to the senior as a thank-you gift upon delivery of their portrait order. We also e-mail them a link so that they can easily publish and share the show. To protect our copyright, each image is stamped with our logo and cannot be downloaded for making printed copies. The result is that the senior gets good images for their site, and they advertise our studio whenever they share their site with friends.

Currently we use www.slide.com/kodak, an online utility, to create the shows. It's simple and has dynamic de-

sign presets. It even provides current music, server space, and—unbelievably—it's *free!* Your results will depend upon the number of images in the gallery and the efficiency of your workflow, but we find that an average gallery can be created and published in fifteen minutes.

Our Most Effective Newspaper Ad

In these times of three-word text messages, the direct and to-the-point approach may be the best way to appeal to seniors and their parents. Everyone remembers the anti-drug campaign with the image of the frying egg and a voiceover saying, "This is your brain. This is your brain on drugs." We started a similarly concise style of campaign with our "Uncle Fred vs. J.D.'s" ads, in which we show a

Snapshots are bad. Professional portraits are great. These to-the-point ads make it clear why seniors should book a session.

To get and hold a teenager's attention, you need to have some flash and glitz. In this shot, adding a fan added a fahion edge—something with big appeal to teenage girls.

poor snapshot of a senior done by "Uncle Fred" and a beautiful portrait we created. The contrast of the two images says it all, "D.I.Y. snapshots are bad. Portraits by a skilled professional are great." The phone always rings after these ads are published.

Multimedia Marketing

To get and hold a teenager's attention, you need to have some flash and glitz. Hopefully, your work speaks of itself, but that alone may not be enough. So, several years ago, we created our own eight- to ten-minute DVD with images, live session footage, and interviews—all set to music.

Creating the first DVD took us several months of frustrating trial and error. Our second took a few weeks—primarily due to the help of a knowledgeable high-school student and advancements in technology. There are several great companies that can create multimedia shows for you, but we prefer the control of doing it ourselves. Be-

ware: you'll need to be ready with some serious hardware and software (*i.e.* Adobe Premiere, Apple Final Cut, Pinnacle Studio, etc.) for this job. If possible, you should also have a special mailer designed (contact Blossom Publishing). If you can't afford to mail it to your entire list, spot mail it to different schools, loyal customers, etc.

For us, the project paid for itself immediately: about 30 percent of the recipients booked sessions and the word of mouth was excellent. You can also create a buzz about your DVD through other marketing: web site, newspaper, e-mails, and possibly strategic texting. Of course, once created, the show can also be the feature in your mall displays, at movie theatres, etc.

It is also possible to render shows for distribution online (*i.e.,* on your web site, Youtube.com, etc.) but due to size limitations and compression, the loss of image quality may be too great of a cost. Also, be aware that YouTube can claim rights to anything posted on its site.

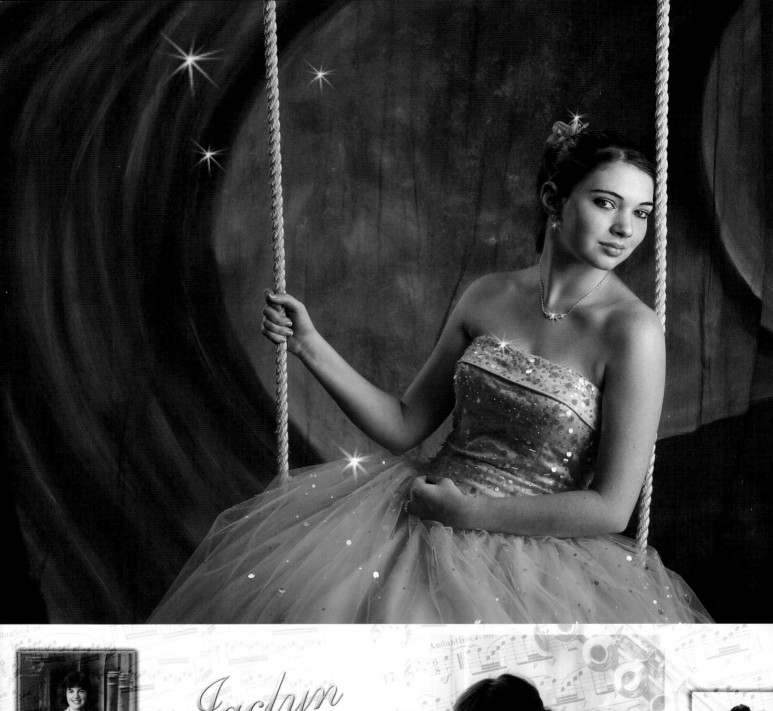
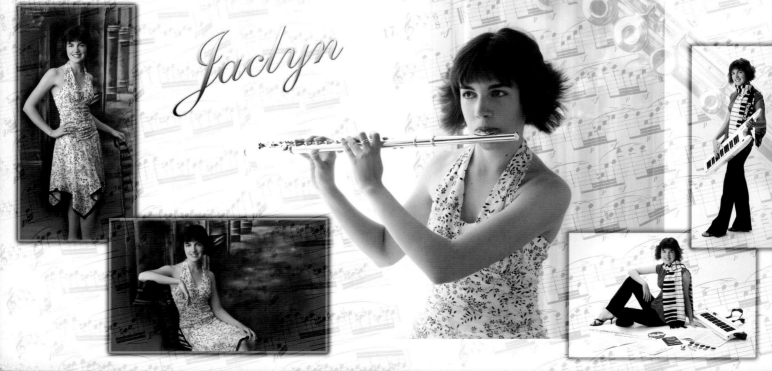

Jaclyn

Senior will go to whatever place seems cool and is most likely to make them look good. As a result, showcasing your best images in your marketing materials is critical.

2. The Sales Workflow

Handling the Initial Phone Inquiry

Marketing is an important job, but it's just the first step in the sales process. When the phone rings and there is a nervous senior or an undecided parent on the other end of the line—someone who is *almost* ready to schedule—there is no one more important at your studio than the person answering the phone. The senior or parent is about to choose you for the most important portrait of their young life. Don't blow it!

Remember: although you've been in this position hundreds of times, it may be the caller's first time ever commissioning a professional portrait. Be sure to identify yourself and ask their name, then use their name in the conversation. Be friendly, not gushy. Be understanding. Let them do the majority of talking; be a good listener. Answer their questions and ask whatever questions are required to get the information you need to fully understand what they want to see in their senior portraits. Find out a time that is best for them, suggesting dates and times that are good for the studio.

Here's a script for a typical telephone scenario. It begins when the phone rings.

STUDIO: Hello! This is Photography by J.D., I'm Wendy. How can I help you?

CLIENT: I'm interested in some information about senior portraits

STUDIO: And what is your name?

CLIENT: Tiffany Smith.

STUDIO: Okay, thank you. Did you receive any of our senior mailings, Tiffany?

CLIENT: Yes, I did.

STUDIO: That's great! What were some of your favorite images on the brochure?

CLIENT: The outside portraits. Everyone likes those.

STUDIO: Ninety percent of our seniors choose a combination of indoor and outdoor portrait sessions. When are you thinking about having your senior portraits taken?

CLIENT: I'd like to do them in June. And I'd like to have a picture with my car in it.

STUDIO: June is a great time—the light is beautiful at that time of the year. Do you prefer a morning or afternoon session? Mornings are preferred for a portrait with your car in the photo park.

STUDIO: The morning is fine.

CLIENT: So a morning is fine, great! How does Tuesday, June 10 or Thursday, June 12 at 9:00AM sound to you? (*Waits for response.*) Great! We'll put you down for a 9:00AM on June 10. Are you thinking about bringing any other special props to make your portraits more personal?

CLIENT: (*Client lists any special requests*)

STUDIO: (*Studio responds to those requests*) Yes, we can do a portrait with your boyfriend, and we can include one with your prom dress and your dog. The prom dress, head-and-shoulders shot in a sweater, and the shot with your shoe collection will be best done indoors—it gets warm in the summer and our air-conditioned studio will keep your hairdo fresh. And, no, there's no extra charge for including your saxophone.

CLIENT: (*Client lists any additional requests*)

STUDIO: (*Studio responds to those additional requests*) Yes we can make any of the images into black & white. It sounds like you've got great ideas!

STUDIO: (*When client has no additional requests*) From what you told me, I believe a combination booking of a yearbook shoot, an inside studio session, and outdoor photo park session will give us time to cover all the ideas we've talked about. Let's see . . . that will take about two hours. Please bring along five or six clothing combinations— and if you want help selecting which are the best, bring more clothing and we'll help you choose. We can also add more clothing selections, but we'll have to schedule a little more time and there is a $10 charge for additional clothing changes. So

I'll repeat what we've all decided to do. *(Repeats the details of the booking)* Does that sound good?

CLIENT: Yes.

STUDIO: Great, Tiffany. Now, I'll need the correct spelling of your name and your address. What's your telephone number? Do you have a cell number? Will anyone be coming with you? Do you wear glasses? Try to be here about fifteen minutes before your scheduled session time so we can have time to chat. Also, would it be possible for you and your mother to come in about a week before your session? We have a pre-session consultation program video and would love to get to know you better. We can also talk about what you're planning to wear and how to do your makeup. You'll also be able to see the marvelous things we can do with your portraits after the session. We have an award-winning photographic artist who can make anyone to look like a model—so don't let a little blemish make you nervous!

CLIENT: That sounds great!

STUDIO: Okay, then one week before—June 3rd at 2:00PM—we'll do the pre-session get-together. I'll put it on the calendar. Tiffany, one more thing. We request a credit card number to guarantee the date of your session. We make no charges on the card unless you miss the appointment.

CLIENT: Can I use my Visa card?

STUDIO: Yes, a Visa card is fine. Thanks for calling—we look forward to meeting with you. Be ready to have fun! Bye, Tiffany!

This is a typical scheduling conversation. If the person is just calling to ask the price of an 8x10 print, on the other hand, you can answer with a few questions of your own:

Do you want it sprayed?
Do you want it mounted?
On what type of board?
Do you want that in a folio?
Is this from a previous session?
Is it to be retouched?
Does it need to be retouched?

Next, we tell them, "We normally include retouching, cropping, art enhancement, mounting on board so it's ready for framing, and the application of protective spray at the regular price of $XX. Not including any of these would give you less than a professional-quality image."

If they respond, "That's sounds fair. I'd like to schedule an appointment," you've got a qualified prospect. If not, let them go to the chain-store portrait department. You can't afford them and they probably can't afford you.

The Pre-Session Consultation

Once a senior has booked, the pre-session consultation is the time to plant the seeds of a larger order. It's a time for you to meet the student and parent and begin to analyze what the session will require to be successful.

The pre-session consultation plants the seeds for a large order.

Evaluate Their Tastes. At the pre-session consultation, greet the senior and parent warmly. Make them feel that they are the only thing that is important to you that day. Let them watch the pre-session video while you remain quiet in the background. As they make comments to each other, listen to what they like and don't like, then record it on their information sheet. After the video, ask for their comments. The more you know about what turns them on or off, the better you can please them.

Show Exciting Products. Bring out samples or give them your catalog of photographic add-ons—entice the senior with products like playing cards with their picture on them for grandparents, a large banner for the boyfriend, their own model memory book of numerous poses, and so on. This is the time to create the desire for a beautiful composite. It's the time to get them thinking that *everyone* gets a large wall portrait in a beautiful frame. Plant the right seeds and you'll reap a great harvest on the sales day.

If we don't have a pre-session consultation, the evaluation and planning for the session have to be done in a short meeting between the senior and the photographer before the session. Being able to do this accurately and consistently depends on the ability of the photographer to become an instant psychologist with every senior session. The more contact and preparation you can get before the session, the better the session will go.

Plan the Session. At the pre-session consultation, we like to have the student fill out a questionnaire about themselves, their hobbies, music, what clothes they plan to bring, what props should be included, etc. We also have them look at sample folios and indicate which poses and backgrounds they like and which ones they do not. Is the senior bringing any personal collection that will take extra time to display? Are their friends to be included? Or are there any requested shots that require a special location or particular time of day?

Evaluate the Subject. We also make mental notes about the senior's personality. How do they relate to their parent, peer, or friend? Does this senior have any special needs? Particularly, we note the students who have an attitude. Is this senior going to require a "high maintenance" type of attention? Is the session going to be "all about me"? Conversely, is the senior shy or lacking in self-confidence?

After the senior leaves, we make notes to use on the day of the session. This helps the photographer be prepared to shoot certain poses to fit that memory book or get the shots that are needed to make a composite of his soccer

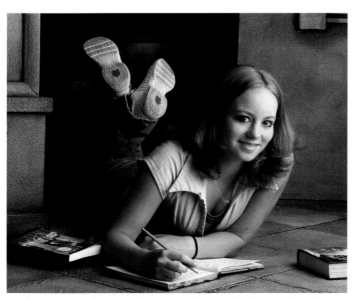

Understanding the senior's personality can help you plan the perfect session.

images. For the photographer, preparation is the key to successfully satisfying the client. It helps the photographer, but sometimes we are still surprised on the session day.

Proofs for Senior Portraits

When it comes to senior photography, probably no subject is more debated than the production and distribution of paper proofs. Let me give you a brief account of the history and development of our studio's present policies regarding the distribution of senior images to view after the session.

Digital Presentation. From what we were told at workshops, the elimination of paper proofs and the opportunity to sell directly after the session were key advantages of digital imaging. However, selling digital images can be a challenge—especially if you have an established clientele that are not accustomed to digital presentations. The following are a few things you should focus on if you decide to go this route:

1. Keep it simple—especially at first. Don't try to overdo it with a big show. Get the fundamentals down first, then add some polish. You can create the greatest looking multimedia production in the world, but it's useless if it crashes or your staff doesn't know how to run it properly.

2. Make your images look their best. Do whatever you can to keep image quality number one. Use high-resolution monitors and projectors that are sharp and provide good color and contrast. It's hard to match a fine print, but you can come close. Install high-quality video cards in any of your computers that are used for presentation.

3. Use tools your clients will understand. Consider what your client needed to do to choose their images traditionally. Sort the images into groups, then edit with side-by-side comparisons. These simple tasks are extremely important. Without a good system for sorting and editing, your sales sessions will last forever and leave everyone frustrated. Software like Levin's Autoframe can help your clients make their choices quickly and easily, just as they did with paper previews. Carefully preset groups can also increase sales by helping your clients remember who they need to buy portraits for—and they can help you remember to mention

If you know the senior has a special or meaningful outfit, having them bring it to the session will result in a must-have image.

certain products (albums, folios, etc.). Using simple "in" and "out" groups can save a tremendous amount of time. Of course, an ordering menu of various sizes and quantities is essential.

4. If you don't print take-home previews, at least print contact sheets for your salesperson and clients to use as a reference when ordering.

5. Show 'em large and show 'em frames! You can't show your images on a little 15-inch monitor and expect to sell 30x40-inch prints (this problem applies to online sales, also). You can't rely on your client to imagine their portrait nice and large. Again, Levin Autoframe's software can show your client's images in the frame of their choice and even on the wall at their home! The ability to show images in albums, mats, digital layouts, black & white, toned, etc., makes for easy add-on sales.

It should be noted that digital presentation works extremely well for some, but not so well for others. Digital presentation was to be our approach for the first year we were completely converted to digital for our senior-portrait photography. In three weeks, however, our orders dropped drastically and a number of scheduled senior sessions were cancelled. What happened to all the excitement and increased orders we were supposed to experience? That was strike one.

Inkjet Proofs. Our next try was high-quality inkjet proofs that were produced the same day as the session. These were designed to eliminate customer complaints about having no images to show Dad, Grandma, or Uncle Fred. Our sales session was then scheduled for the third day after the session. The results? Parents complained it was too fast, it was not yet payday, or that they were not exactly like film proofs. Worse yet, the seniors found that these images would make satisfactory copies at WalMart or on their own scanners. Add to that the high cost of premium paper and ink for us—strike two!

What Our Clients Had to Say. Our client comments can be summarized as follows:

1. Small-town people are in need of something to see, hold, and feel before making a decision. Big-city photographers quit sending out previews

A high school senior reviewing her temporary selection prints (TSPs) after her session.

The sales session is scheduled one week after the photo session.

Temporary Selection Prints. It was based on these experiences and our client feedback that we settled on Temporary Selection Prints (TSPs). TSPs are approximately 3x4-inch inkjet or color laser prints created on matte paper with ID numbers, name, and copyright on each image. They give the client a reasonably good image on inexpensive paper that doesn't copy well. The name "temporary" also gives clients the impression the proofs will suddenly curl up and disappear. Because they are temporary, we do not allow the client to keep them. After all, we don't want them to show their friends something that will soon fade and give them a bad impression of our work.

If they wish, of course, permanent proofs made on professional photo paper can be ordered with the final order. A display board showing the comparison of "temporary" proofs and regular photographic paper prints is shown to clients after each session. The illusion of the impermanence of the TSPs has increased our sales of "permanent proof" folios, which are sprayed with photographic lacquer to guarantee their longevity. Introduction of our "Retouch Lite," using basic print enhancement, also gave our "permanent proof" folios a more professional look and added to our gross sales.

The Sales Session

Currently, our sales session is scheduled exactly one week after the photo session. Longer time spans result in less enthusiasm; shorter time spans make the client feel rushed to decide. One week appears, for some reason, to be the magic time to schedule ordering.

Whatever proofing method you choose, and however long you decide to wait to schedule the sales session, it is recommended that you print your final order invoices *with* thumbnails. This will help you to avoid mistakes in production and provide you insurance against clients complaining, "I thought I ordered X!" To protect yourself further, have the client initial the completed order when they have approved it as presented.

awhile back and their clients accepted it more easily (except for some tenured studios with clients who have conditioned expectations).

2. They don't want to be rushed into a quick choice. If they feel they're being pressured, they will refuse to buy anything.

3. They want a selection of several poses, both indoors and outdoors.

4. They want to feel they are justified in spending more than they planned if the quality of your work is superior to the work of other competitors.

5. They see nothing wrong if they purchase the portraits and copy them later.

FACING PAGE—If you deliver work that is superior in quality to that of your competitors, your clients will feel justified in spending more on it.

Leah

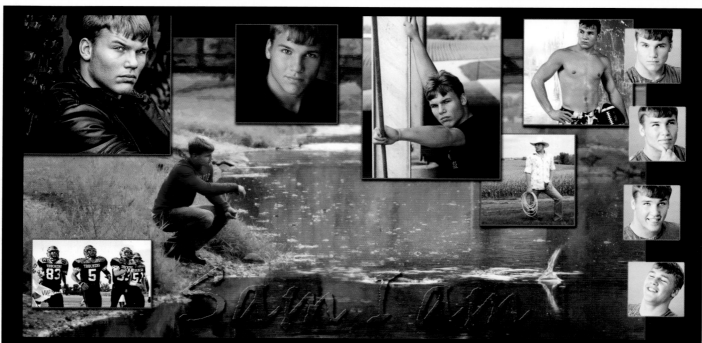

Composites require careful pre-session planning. For more on this, see chapter 8.

3. Your Studio and Equipment

Getting Ready for the Session

The day for the senior session has arrived. Your subjects will be in varied states of readiness—mostly, it depends on the gender. The male will either stuff his favorite t-shirts into a bag, or his mother will have pressed and carefully packed her favorite outfits into a suitcase or travel bag and marched him to the studio. The female will have shopped and fussed over her choices for weeks. On the session day, she'll torment herself over a bad hairdo, do her nails and makeup, then arrive at the studio a nervous wreck.

At this point, the studio staff should be ready to go to work soothing nerves and ironing wrinkles as necessary to prepare the senior for their session. Of course, the photographer must prepare for the session, too—it's time for a final check of the studio and its equipment.

Check the Studio and Camera Room. When you enter the studio, it must be warm and comforting, home-like, and tidy. The dressing area should be roomy and well lit, with places to hang clothes and mirrors for the subject to check their final appearance. The camera room may be impressive, but it should not be overpowering. Use the air conditioning/heat to provide a comfortable environment, and play the music the senior chose on their questionnaire. Every area that clients will see should display a sense of order and have recently vacuumed carpets.

If any of these conditions are not met, the client won't feel relaxed or be confident that they are getting a quality product. It's like walking into a restaurant with a dirty floor, tables full of dirty dishes, and a sweaty cook leaning over a messy grill. So make sure everything is clean and in its place—and that includes your appearance and demeanor. Are you dressed like a professional? Is your attitude adjusted to fit the situation?

Check the Equipment. Be sure the equipment is working and that a backup system is ready to grab in case of a mid-session breakdown. Take a test shot of your assistant to be sure all the captured files are being recorded correctly. Expose a few frames to check the intensity, quality, and color temperature of the light. This step will save

hours later in the processing of the day's files. Finally, make sure all your supplies are ready and that any needed props and backgrounds are in their places. Searching for these while your client waits on the set will *not* make you look like a skilled professional.

Cameras

Our Choices. Currently, we are using the (no-longer manufactured) Kodak 14N digital cameras and the Canon EOS III cameras. The Kodak had a built in luminometer that allows for constant monitoring of every exposure taken. We can check the red, blue, and green values instantly for each exposure. This has helped us to maintain exposure values of all our images within $\frac{1}{10}$ stop. This makes maintaining the consistency of our images very easy, saves time in processing, and optimizes the flesh-tone quality. The Canons, on the other hand, do not have a built-in luminometer, so more quality controls and light checks have to be done outside the camera. Both cameras produce excellent images.

Resolution. Modern digital cameras have so many megapixel possibilities, it may be difficult to choose the size best for high school senior photography. The more pixels available to create the image, the sharper and more color-accurate the image will be—and higher-resolution images can be enlarged to a greater extent.

So, one may ask, "Why not get the biggest megapixel camera available to do my senior portraits?" Here's the answer: How big are you going to make those senior portraits and is the amount of time you spend processing images important? With the larger cameras, boasting close to 22 megapixels, you could make billboard size prints, but it will add considerable time to your workflow. To fully process sixty images from a senior session in a reasonable amount of time, a much smaller number of megapixels is desirable.

If your senior orders don't typically include portraits larger than 16x20 inches, we have found that 10 to 11 megapixels will be plenty. In fact, we did many excellent

16x20-inch images with our old Kodak cameras, which had only 6 megapixels. Carefully monitoring exposure, modifying the light conditions, and having a quality light shade and tripod are more important to producing quality images than a massive number of pixels.

Know Your Stuff. The camera is only a tool; it's the photographer using it that determines the quality of the final image. Master your camera's controls and what settings to use with each lighting scenario so that you do not have to fidget and fuss over your equipment during the session. The senior will quickly pick up any lack of confidence you have in your ability or equipment. This lack of confidence will quickly transfer to the senior's expression, as well. They will get nervous and feel that your frustration is with them, not your equipment.

Lighting

Like your camera, your lighting equipment is only another tool for you, as the artist, to use. Whether you use one or many lights will depend upon your ability and style. In our studio, we use from one to seven light sources, depending on the style of portraiture we wish to portray. For senior photography, we usually employ a four-light system.

Main Light. Our favorite main light is a Profoto lamp head in a Larson 4x6-foot softbox. With the constantly changing senior poses, this allows us to go quickly from head-and-shoulders portraits to full-length portraits on a large set. The quality of light from such a large source is excellent and allows us an infinite variety of uses.

Fill Light. Our fill light is a Profoto lamp head in a 2x4-foot homemade gator-foam reflector. This is mounted high in the ceiling of the studio. With the 4x6-foot main

light, the importance of the fill is decreased, so it is used sparingly.

Background Light. The background light is a Photogenic 2500 monolight used as necessary with a variety of reflectors and gels to provide separation between the subject and the background.

Overhead Light. The overhead light is another homemade softbox, a 2x6-foot model, powered by two Profoto lamp heads that provide separation as necessary. In some situations, when a more directional overhead light source is required, this unit is replaced by a portable Photogenic head with a honeycomb grid and barn doors.

Window Light. When soft, natural light will best flatter the senior, we use our north-light window area. In this situation, we utilize only the light supplied by the light from the window and direct it where needed using reflectors and scrims.

Backgrounds

Ease of Use Ensures Variety. Our background displays include a twelve-roll power unit with remote control, eight rollers with a pulleys/chain setup, and a variety of ever-changing muslins on wires—plus a collection of three-dimensional sets. The more variety you have available, the easier it is to change backgrounds quickly. If your backgrounds are not easy to change, by the middle of the senior season you may find that you are using the same ones over and over again. As a result, your images will have a look of "sameness."

High-Key to Low-Key. Not having the luxury of a separate high-key camera room, we have to use our single camera room for both high- and low-key shots. A trick that

A Profoto lamp head in a Larson 4x6-foot softbox provides great flexibility on the set.

A wide variety of backgrounds and a convenient system for changing them are important for providing the variety seniors desire.

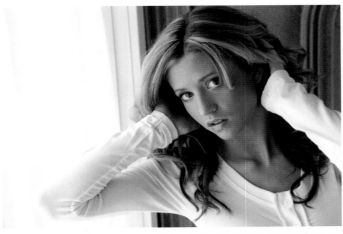

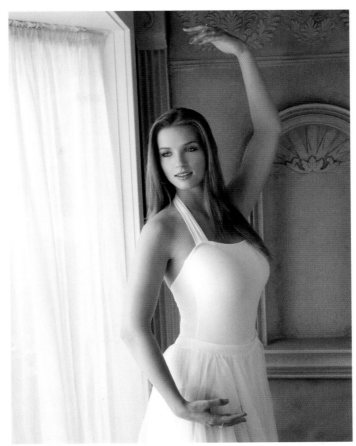

ABOVE AND LEFT—*Window-light portraits have a soft, natural feel.*

The high-key background setup in our camera room.

A patriotic background being created with the projection flash unit.

has allowed us to create a quick high-key set is to use two panels of high-gloss Colonial white masonite and a roll of white seamless background paper. The subject stands on the masonite, and the paper (tucked under the masonite) forms a cove behind them. On this set, we use our regular lighting system plus a 2x8-foot homemade overhead strip light that is aimed slightly toward the background. Because of the direction of the light, the seam between the floor and paper is invisible. In fact, we've done many award-

winning high-key images using this arrangement and no one has ever detected the seam.

Projection Flash Unit. A projection flash unit with an assortment of projection discs, or "cookies," can help you to create a variety of backgrounds. Our favorite unit came from the Tallyn Co.

Colored Gels. A large collection of colored gels enable the photographer to match most desired background colors. If limited space in your studio makes it impossible to

LEFT—*Colored gels offer your studio endless background possibilities.* **RIGHT**—*There's no limit to what you can do with backgrounds once you bring your images into Photoshop. This image also shows the use of simple nesting boxes as a posing prop.*

store multiple rolls of colored background paper, illuminating a roll of black or gray seamless paper with gels will be a good substitute. Using a combination of gels at the same time can create interesting effects.

Digital Backgrounds. Just think of all the original, one of a kind, things you can do and the backgrounds you can create with the help of your computer that no contract or chain store photographer can create.

Simple Posing Tools

Posing tools that anyone can build or obtain locally include a 3-foot wooden step ladder, wooden bar stools and step stools, and small tables that the subject can lean on.

Stepladders. If we had to choose one posing tool, it would be the small wooden step ladder. The subject can sit on the top step or put one foot up on a lower step to create a leaning pose. It can also be draped with muslin or act as shelving for displaying items. We have several ladders painted in a variety of colors. Try to have some in the area school colors to use for athletic collection poses or buddy poses.

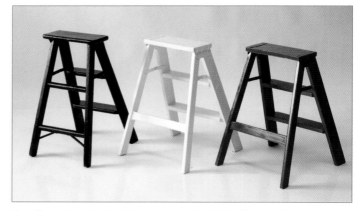

Small wooden stepladders are invaluable in the studio.

Nesting Boxes. A set of five black-and-white nesting wooden boxes in assorted sizes are a necessary part of our camera room. These can be used as part of the set, for sitting on, for displaying other props, for supporting other backgrounds, or be covered with muslins.

Director's Chairs. White painted director's chairs, with a variety of colored cloth seats and backs, can also add a splash of color when photographed on high-key back-

grounds. Personalization with stick-on boat letters using school colors is always an option.

Wooden Chairs. We have found old wood parlor chairs to be great posing tools. Check for them—and other potential posing tools and props—at secondhand stores, the Goodwill store, or garage sales. With a little paint and repairs, you might be able to produce a prop your seniors

will love. Don't be afraid to experiment with bright colors that accent seniors' clothing.

Sets and Props

Large, three-dimensional, commercially produced sets were beyond our budget in the early years of our senior business. Instead, during the off season, we constructed everything we needed ourselves. These sets were functional, but heavy. Financial success with these homemade large props led to their demise, and they were replaced with commercial sets. These are easier to move, so they can serve as props for events like proms and dance schools as well as for in-studio senior portraits.

Director's chairs assist in posing and add a splash of color.

ABOVE AND RIGHT—*Wooden chairs are a helpful posing tool to have on hand.*

Display Grids. Store display grids can be purchased secondhand from commercial display companies. The grids, when hung from the camera-room ceiling, make displaying the senior's sports uniforms much easier.

Painted Lath. Painting a number of lath boards can make it simple to add a graphic and colored accent to any

Lath boards can be painted in a variety of colors to create graphic backgrounds.

ABOVE—*Suspended grids are helpful for displaying team uniforms.*

ABOVE—*Block letters and numbers are favored props in some areas.*

set. We have several sets, painted in local school colors, to include in sports collections.

Block Letters and Numbers. Large numerals or letters that indicate the class year or spell "senior" are loved by some school areas and disdained by others. Your market will dictate whether or not these are a useful addition to your studio's holdings.

Room Dividers. Portable room dividers cane be found at garage and rummage sales or stores like Pier 1. Rice paper screens, three-section changing screens, and variety of wicker panels are all useful. The screens and dividers—paired with a few props, like vases with flowers and a roll-out bamboo floor—enable the photographer to quickly construct many different senior-portrait sets.

Variety is Critical. In addition to the items listed above, we have an extensive collection of fabric pieces, rugs, wall hangings, window frames, chairs, bean bag chairs, and other set-design elements. Every year, we also purchase a commercial set that's new in our area. This mix-and-match collection allows us to create a wide variety of unique sets for senior portraits. It also prevents us from

Check Their Reaction

Check the senior's feelings about any props you add to the set. If the senior didn't provide the prop, don't assume he/she will like your choice. You can get a sense of how the senior feels about the set up with a quick, "How do you like this?" There's no use wasting time on something the senior does not like and certainly will not purchase.

getting burned out by doing the same setups all season long. When a particular set or prop becomes too recognizable (or associated with our studio), it's time to put it into storage or replace it. We make an effort to recycle things every few years to other studios. You may even be able arrange a mutually beneficial trade with another studio, so you both get something new to work with—and at no cost.

Other Handy Items for the Camera Room

Trends change, but there are certain items that you can have in the camera room to make you life easier.

Tool Kit. Being able to display the senior's props and collections in a quick way will allow for more time taking portraits and less time preparing to do so. To facilitate set-

Room dividers can be used to create quick sets for senior portraits.

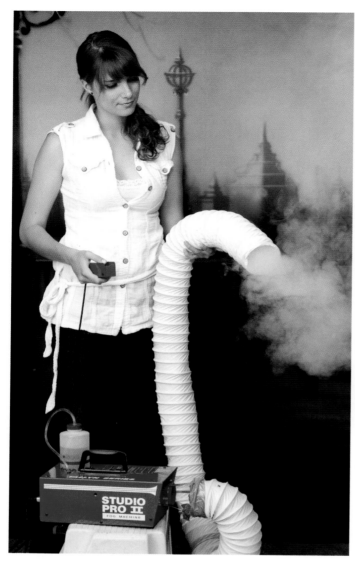

LEFT—*Using a smoke machine is a quick way to add a little mood to yur images.* **ABOVE**—*Add a little heat to your image with some rubber cement.*

ting up these displays, have a little tool kit handy with items like gaffer's tape, picture wire, handy tack, masking tape, safety pins, stick pins, fish line, clips, assorted short pieces of 2x4 wood, bean bags, clamps, shears, hammer, pliers, small mirrors, black markers, Kleenex, towels, spray cleaner, and a lint roller. We have all these items within easy reach in our camera room.

Rubber Cement. Fire can be added to any image with digital skills, but greater realism can be achieved with the use of rubber cement. (*Note:* The need for extreme safety precautions cannot be overstressed here. Make sure you have a fire extinguisher and fire blanket close at hand. Do not try this technique in a small studio or anywhere there are ignitable materials nearby or overhead. For beginning photographers, we recommend placing the flames on any object using Photoshop techniques or having a photo lab do it for you.) For use with the rubber-cement technique,

we have a baseball bat, baseball, basketball, and football the the backside of which we have attached a small strip of aluminum foil. This is where we place rubber cement to fuel the flame, which lasts about ten seconds. During the burn, we turn off all camera-room lights, take a one-second exposure, then remotely fire a strobe on the subject at the end of the exposed time.

Smoke Machine. A stage smoke machine can add mood to a foggy London set or be used with gelled lights to create a mood for portraits of seniors playing instruments. A bit of warning: be sure to employ the type of machine that uses a water-based liquid to create smoke. Smoke from the oil-based liquid will cover your studio with an oily film. The smoke machine from the Tallyn Co. has worked well for us.

4. Posing and Expression

When the Senior Arrives for Their Session

The process of achieving great poses and expressions begins before your subject even enters the camera room. When the senior arrives at the studio for their session, welcome them warmly—don't just leave them standing in the waiting room. If you can't greet them personally, be sure the staff does so and makes them comfortable. Compliment them on something, help them hang up their clothing changes, and do whatever you can to make them feel positive and comfortable.

Check your notes about the subject from the initial telephone call and/or the pre-session consultation, then show them the dressing room and bathroom locations. Don't even approach the camera room until you've reached a point of relaxation between you and the senior. Continually ask them questions about themselves to expand on the things you noted in the pre-session interview—and don't forget to keep the compliments coming.

Expressions Sell Portraits

Forget About the Big Smile—At Least for a While. Parents all want to have their children with a happy, toothy smile for their senior portraits. Apparently, if the child looks happy and satisfied with life, it somehow indicates that the parent has done a great job of parenting. Usually "Smile!" is the last order the teen gets when leaving for their senior-portrait session. For most guys, this is just one more parental order their adolescent psyche wants to oppose. The girls find it less offensive, but they really want to look seductive like their television idols. In any case, a big smile is not what the photographer is likely to see in the first image. The best approach is for the photographer to forget about needing a big smile and first just begin a normal conversation. If you gain their trust and confidence, a smile will come eventually.

Use Music to Set the Stage. Music is the best common denominator, so put whatever the senior likes to hear on the stereo. Talking about the different musical artists, rather than the senior himself, is a good path to take when opening up communications. (*Note:* Many studios have added Sirius/XM satellite radio to their camera room. The stations are commercial free and the variety of channels assures having the student's favorite style of music.)

The Guys. Whether it be conversation about sports teams, NASCAR, hunting, or their wheels, familiar subjects seem to break down the defenses for our senior guys

Conversation is the best way to loosen up your senior guys for their sessions.

best. Once the senior guy determines the photographer has interests in something other then photography and getting him to smile, the conversation is less guarded and can lead to a more comfortable session.

Doing a series of macho images gives the senior guy some shots that reflect how he likes to picture himself as being. If you suggest to him that the girls would probably like a few more kindly expressions, a soft smile usually is possible. Toward the end of the session, talking about some of his favorite activities—especially ones in which he has had success—will usually elicit a smile with teeth showing. If not, you already have a sly grin on file in the camera.

If the guy has a girlfriend, her presence will always help bring out a great expression. Tell her, separately, that you'll need her help to get the good smile his mother wants so badly. Most girlfriends will know what to do. When guys do not have a girlfriend, or one in the camera room, some flattery from our pretty camera-room assistant will usually be able to get an expression that is satisfactory for his yearbook portrait.

The Girls. With senior girls, there are a variety of possible paths to getting a suitable image. First, try to get a feel for what type of portrait she is after. Use your experience to determine the expression she is really intent on getting. Read between the lines; what she is *saying* she wants may not be what she *really* wants. Take time to speak with her before the session. Show her several examples of portraits you've done for other senior girls in the style she's

described that she wants. Which ones are her favorites? Are they happy, moody, sexy, fashion, closeups, or full length shots? Look for trends and decide whether she is choosing a certain style on her own or whether is she following what others have told her is best for her.

Control the Session

You must be the one in control of the session, so steer the conversation and remain in constant eye contact. Give your subject the feeling that he or she is the only important thing in the world—at least at that moment. Don't waste any extra movements on light adjustments or camera settings. Just give posing instructions and shoot. Keep the chatter going constantly, and keep reading the subject's reactions to your comments.

Provide Feedback. Give positive reinforcement repeatedly. When you get a pleasing image, stop and say something like, "Wow, this is great—you've got to see this!" Then, take a short break and show them the LCD screen. If the senior reacts the same way, with a "Wow that's great!", stop and change to the next outfit. Keep the excitement rolling. If you're not enthusiastic for the whole session, the senior will not be either. This is not easy, senior after senior, day after day, for the entire senior season— but that's why you are called a "professional!"

When They've Loosened Up, Get More Creative. When you have reached that point of overcoming the senior's first nervous apprehensions introduce some just-for-fun poses. You've built up their confidence and enthusiasm, so go for some poses with varied facial expressions. Keep it going by adding some of their personal props— but, all the time, keep them talking to you. Let them know you're interested in them and their future. (*Note:* With shy seniors, we often wait until this time to do the head-and-shoulders yearbook portrait. Doing it earlier in the session will capture a lasting image that reflects their lack of confidence in the eyes.) Some students who are overweight or have facial problems (like a crooked nose, scars, very long neck, etc.) will accept the photographer moving lights or the camera angle at this stage in the session, because they have become confident that it's being done to make them look their best.

Have Fun. If you have used your photographic skills and applied teenage psychology, by the end of the session everyone will be having fun. Many times, even students who came in feeling very nervous and shy will express the

fun they're having and regret that the session is completed. Tell them how well they did and how great they looked in all the poses. Express how eager you are to see the final previews and that you can't wait for them to receive them. You might even suggest to them certain poses that would make wonderful wall portraits for their home.

Tell them you will need their signature and their parent's signature for permission to display some of their images. This way, they will leave with a good feeling about how good they must have looked. Their enthusiasm leads to bigger orders and creates positive word-of-mouth when they talk to their friends about their wonderful experiences at the studio.

Posing Separates the Professional from the Amateur

In chapter 3, we discussed a variety of supplies and equipment that are useful to the senior-portrait photographer. These could all be purchased if one had unlimited funds. For that matter, the studio itself and even training could be purchased. If this was the end of the story, though, everyone with sufficient funds could become a professional photographer. The one big intangible, however, is talent. Unless you have the innate skills, you will be limited in your photographic successes. All the practice, marketing programs, and equipment mean nothing if you cannot produce an image that satisfies your client. This is the time to perform or fail as a photographer, a businessperson, and an artist. The pressure is on.

Why are we mentioning this now? Because now is the time to separate yourself from your competitors. Can you relate to your subject? Can you instantly analyze the subject's facial structure and body posture? If you can, you'll be able—with practice, of course—to pose and light your subject in a way that creates the most pleasing view of them.

You can pass up your competitors if you can learn to pose your subject well. Uncle Fred—even with his new $2000 digital camera—will never be able to capture the quality of portrait you can deliver, because he lacks your understanding of what it takes to make a subject look their very best. This simple fact will guarantee the future of portrait photography artists.

A Systematic Approach to Posing Seniors

Have you ever heard, "That's not his smile" from a senior boy's mother when reviewing his images? How can that

Avoiding Burnout

Senior photographers do burn themselves out. You are at your creative best in the early senior season. This is the time to try out new poses and experiment with new sets. Your artistic creativity will be at its peak several weeks into the season.

So how are you to be able to keep your energy high and be enthusiastic to be able to keep producing great senior images toward the end of the season? The answer is to divide up your senior season. We used to try to photograph the whole day, six days a week, throughout the season, with no breaks. We were always trying to see how many seniors we could do in a season. Then we realized we were becoming a factory. We wanted to be photographic artists and have opportunities to utilize our creativity, so we decided to increase our prices, lengthen our session times, and do fewer sessions per day. We hired more help to do handle other tasks and started spending more of our time creating images.

Doing fewer sessions per day allows us to remain more creative— and it has actually increased the size of our orders.

When we made this change, our orders actually increased in size, allowing us to see more income while doing fewer sessions. This trend has grown, and we now schedule definite breaks throughout the senior season. We teach a week-long PPA Photography school session, take weekends off to be with family, and do more location shoots and commercial work to keep ourselves fresh.

As a result, our enjoyment of the photographic art has returned and senior burnout has been avoided. As you can imagine, a happy, less stressed senior photographer will find his subjects to be happier and more fun to photograph.

be? How could that happen? A study of posing may reveal the answer.

Posing is a skill, not an accident. Although, many seniors are inherently graceful and position themselves attractively, many don't. It is our job to *make the subject look their best*, which may mean a little better than normal but also natural—as if that's how they always look.

A pleasing pose doesn't just happen. There are plenty of distractions on a set that can impede the subject's comfort. If the photographer is not skilled at directing subjects and putting them at ease, it will show in the final image.

The balance of this chapter contains a systematic approach to posing seniors. It is by no means a complete manual (for that, may we recommend our book *Master Posing Guide for Portrait Photographers*, also from Amherst Media), but it provides the building blocks that will assist you in posing almost any senior. It would be much easier if our seniors would come in to the studio, hand us a card that they were given at birth with a list of their "best poses," but they don't. That means it's our responsibility to quickly identify those poses and apply them in the best way possible. To do this, we need to practice and gain experience, filling our little black bag with options to grab at a moment's notice.

Five Basic Posing Concepts

First, we'll explore five posing concepts, followed by five poses of a senior girl, five of a boy and five couple poses.

The 80/20 Rule. Posing is not all, or even *mainly*, about moving body parts. The most dynamic physical pose

won't work if the expression isn't there—remember: expressions sell portraits! Expressions go beyond getting the subject's natural smile, to the twinkle in the eyes, the proper posture, a dynamic lean, etc. Expressions come from the heart, so getting the right expression is actually an exercise in controlling the subject's mental attitude. So, only about 20 percent of a pose is physical or mechanical; 80 percent is a mental game.

The Mental Game. To optimize a senior-portrait session and create exceptional images, you must work toward building an emotional connection between the client and yourself. You don't need to be their new best friend, but you need to get to know them well enough to make them relax and feel comfortable. Their portrait session is a new, and sometimes scary, experience, with effects similar to public speaking. As noted in chapter 2, this makes the data gathered in a pre-session consultation a very valuable resource; it gives you information about them that you can use in conversation. If you sincerely take an interest in them and their interests, they will relax and trust you. Reassuring comments and complements are always effective as is avoiding "dead air." Nervous chatter isn't calming, but dead air—a total lack of any conversation—can build outright fear in a client. Just think how much you like it when you go to see your doctor and all they say is "Hmm . . ." It definitely doesn't put you at ease.

Here are some techniques that work well to maximize the positive energy and open communication:

1. *Do your homework and practice.* Know your camera, know your lighting, organize your props, etc., etc. The portrait session is not the time to be reading your camera manual or flipping through the camera's function menus. Avoid "chimping" (scrutinizing your LCD on your digital camera). You may be just checking your lighting, but the senior won't know that. They'll think you're analyzing them—and that maybe you see a new pimple that just popped out on their forehead.
2. *Demonstrate the pose.* Make it a practice to actually do the pose yourself. It is much easier for them to mimic you than to understand a verbal explanations of "turn this" or "bend that."
3. *Keep your poses fast and fresh.* Don't dwell on a single pose for so long that the senior becomes stiff and uncomfortable. They will get frustrated and

that will show in their expression. With digital capture, it costs almost nothing to push the button. Sometimes, it's better to just take the picture—even if everything isn't exactly the way you want it—and then tweak the pose and/or expression for the next frame or move on to another idea. Shooting a few extra images won't cost you much and it can do wonders for the senior's confidence, which will make the rest of the session easier and more productive.

4. *Don't touch.* Avoid intruding on your subject's personal space by touching them excessively. Reaching in and grabbing an arm or cranking a head will instantly freeze them and make them tense. Usually, showing the pose or directing with a tipped hand or finger can do the job. If you exhaust your options and must touch the senior, only touch a hand or maybe hair—and only after asking first. As noted on page 42, it's always helpful to have an assistant do it for you, if possible.

5. *Use humor.* You don't have to try to be a comedian, but some tasteful and appropriate humor can give a boost to a session in which the energy level is weakening.

6. *Build the energy.* Approach each image as a building process. Position the senior in a pose, adjust the clothing and hair, finesse lighting if absolutely necessary, tweak the pose, and then build the energy with excitement. If you've already established a connection between you and them, showing your excitement about how terrific they look and how great their images will be often yields a spark of excitement that will beam through in their expression. Be ready—peak expressions don't last very long!

7. *Listen to feedback and adjust.* Often, a senior, family member, or friend in attendance may comment negatively about a pose. This may be because they don't see what you see from their angle or understand the lighting—but keep in mind that they know themselves better than you do. So, be aware of any negative comments or gestures and use that information to adjust and customize your posing efforts. Also, file away any positive comments in your memory to possibly re-apply later in the session.

8. *Handle problems quickly.* Many times, through no fault of your own, problems will occur. The senior and their parent(s) may disagree, or something like complexion issues or a bad hair day will color their mood. Do not ignore these concerns. As a professional, you need to resolve the problems— or at least reassure them that the problems aren't as serious as they may think. Getting caught in a battlefield is no fun; you may never make a good connection with your senior subject and the chance of capturing great images is diminished.

The Mechanics of Posing. Seniors are not robots or dolls that can be bent into place. The laws of geometry, physics, and physiology set limits as to what can and cannot be moved, bent, turned, etc. The same laws also provide hints about how, in mechanical terms, to build poses.

1. *Flattening.* Consider the fact that photography renders three-dimensional forms on a two-dimensional plane. You've probably heard, "The camera adds weight." (*Note:* We've looked and can't find a menu entry on our cameras that says "Add 10 Pounds" or "Add 20 Pounds"—but we're hoping to someday develop "Subtract 10 Pounds" and "Subtract 20 Pounds" settings!) When you convert three dimensions to two, it seems like that extra dimension needs to go somewhere . . . and unfortunately, it gets added under the chin, along the waistline, etc. That's one challenge that needs to be acknowledged when posing a subject.

2. *Gravity.* The law of gravity means we're constantly being pulled down. This is another factor that doesn't have very positive effects on our bodies. If anything, it makes us appear heavier. Seniors still have better skin and muscle tone to fight this battle than those of us who are a little older, but it's still another challenge.

3. *Body Symmetry.* We are built out of many sets of body parts (two eyes, two shoulders, two hips, two knees, two feet, etc.). Some of them can't be moved independently—you can't move one shoulder without moving the other, for instance. Trying to pose a senior in impossible arrangements will be painful and frustrating. So, again, there is a challenge that needs to be met.

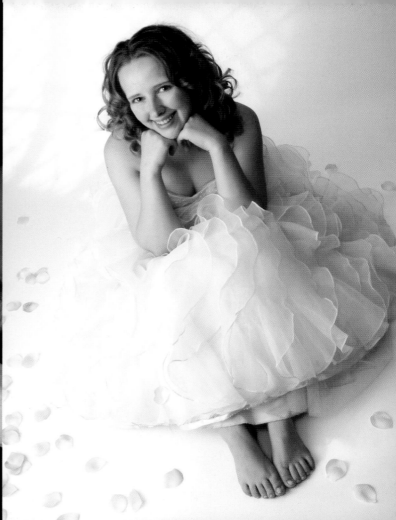

Posing doesn't just happen. It takes skill and experience to pose your subjects in flattering ways.

To fight gravity and the unflattering placement of that extra dimension, pose the senior in ways that exaggerate opposite forces. This is accomplished primarily through stretching and good posture.

Start by identifying the point(s) where gravity is pulling on the subject. If they're standing, it would be where their feet touch the ground or floor. If they're sitting on a chair, it would be where their backside meets the chair, etc. Even if you're only photographing their head and shoulders, pose from the ground up, away from the gravity point. Doing so will carry the pose on up through the entire body, all the way to the eyes.

Just before capturing the image, encourage them to stand up or sit up a little straighter and lean toward the camera. This will fight the effects of gravity by stretching critical muscles and body mass and make them appear to be thinner. The lifting effect is similar to how high heels make a woman stand and walk more erect, almost as if helium balloons were attached to her shoulders.

Next, start using the connection of body parts to your advantage. Traditional posing promotes the use of S-curve poses for females and C-curve poses for males. We haven't had a senior come in for their session with an S or C painted on them yet, so we've had to find other methods to create such positions.

Recognizing posing lines is a key. If you view the subject and mentally draw lines connecting pairs of body parts (through the eyes, the shoulders, etc.) and then change the angle of the lines so they are not parallel to each other, you can construct a variety of attractive poses. If, on the other hand, a subject is standing flat and square, the lines will be flat, parallel with the floor, and probably quite boring. If the subject leans, the posing lines will become diagonal and more dynamic.

For a female, tipping the posing lines alternately (head/eyes one way, the shoulders the other, and so on down the length of her frame) will force her body into a curvaceous zigzag form that is very attractive and graceful. If you mentally draw a line through the center of her entire body, that line will show S curves. For a male, tipping the posing lines in the same direction toward a converging point will force their body into a dominant masculine form. Drawing a line through their body will show a C curve.

Once you can visualize the posing lines, you can enhance your posing by working with key posing points and planes, building triangles, and controlling balance.

Key posing points are the eyes, hands, and feet. Careful positioning of these elements can be a make-or-break issue. Pose them well and they can enhance the portrait; pose them poorly and you may ruin it. Good posing of these points is usually determined by attitude and gracefulness. Tipping the head slightly downward and having the senior (especially girls) look upward shows more of the whites of the eye and is beautiful. Except maybe for boxers, it's best to show the edge of the hand and to show it at an angle—not the back of the hand with all the bumpy knuckles. Aligning the feet (especially for girls) aligns the legs and has a slimming effect. Shifting the weight to one foot helps to minimize a flat-footed, droopy posture.

Maintaining overall balance to a pose is essential to keeping the senior comfortable. If a pose stretches them to a point where they feel like they might fall over, or if the pose is too tight and cramped, it will make them look unbalanced and may show in their expression. Triangles are a good shape to keep in mind, because triangles are both dynamic and well balanced. If you mentally draw lines from the top of the senior's head out and down in an inverted V shape and then connect the two lines at the base, a triangle should be formed. Generally, the wider the triangle is at the base, the more balanced the pose will be.

Awareness of the body planes and their relationship to the primary light source is also essential. Imagine the senior wearing a sandwich board to illustrate the plane of their upper torso. If you turn them directly toward the light source they will be fully illuminated, creating the illusion of added weight. Turn them away from the light source and that plane will fall more into shadow, which will create the illusion of less weight and enhance the detail and color saturation of their outfit. Imagine their head is a stop sign mounted on their shoulders. Similarly, the angle at which you turn their head toward or away from the main light source will determine its illumination and apparent width and weight.

Also, management of light traps (like spaces between arms and the waist) is necessary to avoid the illusion of added weight. If arms are at the side, without separation, the width of the subject is mentally judged from the outside edges of the arms (from side to side) rather than based on the width of the waistline alone.

Get Some Elevation
Photographing from elevated camera angles (above the subject's eye level) can encourage flattering stretches in the pose and help to hide the unflattering effects of added dimension.

The standing C pose. Notice how, from head to toe, the lines of the pose converge toward one point.

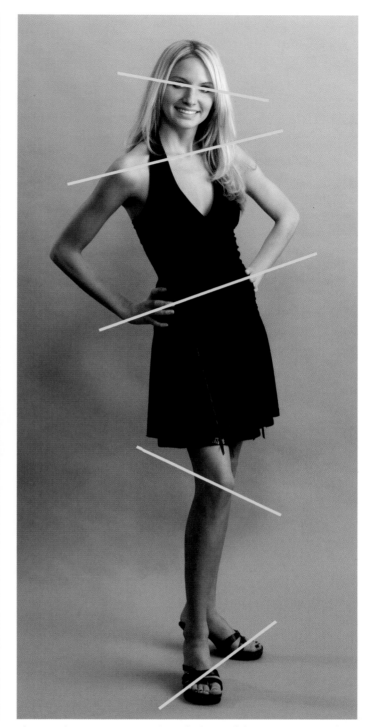

The standing S pose. Notice how the lines of the pose alternate from head to toe.

Posing Goals. Again, your overall mission should be to make your subject look their best. Striving to reach three sub-goals will help you complete your mission: Complement, Correct, and Convey.

In order to pose a senior in a complementary way, you first must identify their positive and negative attributes. Try to do this early, as you meet and greet them. Some-

times, they'll come right out and tell you if they have a particular concern. Other times, especially if you will be spending a large amount of time working with them, you might just ask them what they like and dislike about their appearance. This is best done during a pre-session consultation. Once you've made this analysis, simply pose them, light them, and use camera angles that accentuate

their positives and disguise their negatives. For example, for someone with particularly striking eyes, be sure to position them and get light to them to maximize their attractiveness.

Corrective posing is executed to minimize the appearance of a problem area. Excessive weight is a common problem. Divide and conquer weight by using props—windows, doors, etc.—to break up the mass of the body. If you don't see the whole problem area, it creates the illusion that the problem doesn't exist. Be sure to avoid accent light on large ears or noses, etc.

Posing to convey a mood is the most challenging, but if you can achieve it, you'll be able to create outstanding portraits that capture the subject's inner soul and really show *them*. Doing so will certainly draw attention to your work and create positive word-of-mouth. Your portraiture will have genuine benefits above your competition and your sales will soar.

The easiest mood to develop and capture is that of having fun. If you're confident and having fun, the senior probably will have fun, too. Experimentation, excitement, playing music, and letting them be themselves will be fun for everyone.

Other moods need development through understanding the individual and their interests. Simply identifying their personality type and exploiting it is the best way to encourage and capture these moods. If they're silly, act a little silly and they probably will, too. If they're more quiet, maybe into reading or art, speak calmly and don't try to force them to smile.

Pose for Sale$. As you gain posing experience, you'll find poses that just seem to work—they sell consistently. Sometimes, you won't even be able to determine why. You'll also find certain poses just seem to work for certain types of individuals and not for others. Shooting a series of images of the same successful pose but with little variations (cropping it differently, shooting from different angles, using different backgrounds, etc.) can be very efficient. Again, the more you shoot, the more confident the senior will become—and they'll never realize that you didn't change their pose for every image.

The senior, the senior's parents, the senior's grandparents, and the senior's girlfriend or boyfriend may all prefer different styles of portraits with different poses. Always pose for varied tastes so you can sell several different images.

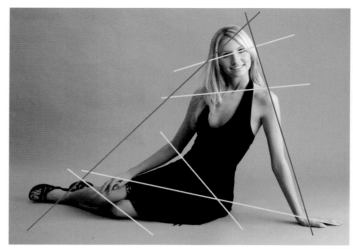

The ski-slope pose.

The standing S pose.

The leaning pose.

A feminine head-and-shoulders pose.

If possible, pose the senior to make scenic portraits. If you position them as a smaller part of the overall scene and incorporate more of the environment, you'll increase your opportunity to sell larger wall portraits. In order for them to be large enough to see easily, the larger print will be necessary.

Top-Five Senior Girl Poses

The Ski Slope. The ski-slope pose is an easy, sitting-on-the-ground pose with excellent balance. It provides a wide triangular base and long, dynamic diagonal lines.

The Standing S. With clear alternating posing lines, this classic female pose is slimming, yet it helps to define body curves.

The Lean. The lean is a very graphic and dynamic pose that will not work for every subject and every outfit. It exaggerates the feminine S curve and is very effective for posing a series of images: full-length, three-quarter-length, and even tight head-and-shoulders portraits.

Head and Shoulders. Depending upon the subject's build, hair, and facial shape, several poses can be used for girls' head-and-shoulders portraits. However, tipping the shoulders and tilting the head toward the higher shoulder is always the most feminine look.

Hands. In this crossed-arm pose, known as "The Butterfly," the wrists are bent, the hands are shown at the edge, and the fingers are long and beautiful.

A graceful pose for female hands.

The mountain pose.

The leaning pose.

The standing C pose.

A masculine head-and-shoulders pose.

Top-Five Senior Boy Poses

The Mountain. The mountain pose is a very easy, ground-level pose for senior boys—especially if you show them how to position their legs. Tipping the head toward the raised knee forces all of the posing lines to converge, creating a very masculine C pose. This is a very comfortable pose and can yield several good images when photographed for different crops, at different angles, etc.

The Standing C. Start by turning the subject to the side and having him shift his weight to his back leg. This will tip most of the posing lines in one direction. Tip his head toward his lower shoulder to complete construction of an elongated C.

The Lean. This is probably our favorite, multifunctional pose for senior boys, because it works for almost everyone. Provide a three-foot wooden ladder for the boy to put his foot on, have him lean his arm on his leg, tip his head to his lower shoulder, and that's about it. You can do several images with this pose, including an excellent head-and-shoulders portrait. Give your subject a ball and the same pose works great for sports portraits, as well.

Head and Shoulders. Depending upon the subject's build, hair, and facial shape, several poses can be used for guys' head-and-shoulders portraits. Just be sure to keep the head tipped toward the *lower* shoulder, which is masculine, not the higher shoulder, which is very feminine.

Hands. As when posing girls' hands, try to show the edge of the hand and avoid too many prominent knuckles. A closed hand is good for boys, as long as they don't close it too tightly, straining the knuckles and shortening the fingers.

Top-Five Senior Couple Poses

The Mountain and the Ski Slope. This is an excellent couple pose for several reasons. It's an easy and comfort-

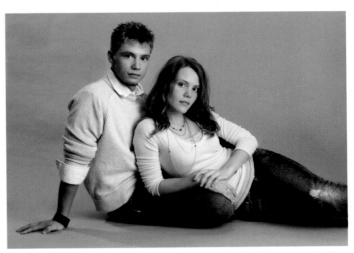

The masculine mountain pose is paired with the feminine ski-slope pose.

A masculine pose for the hands.

A head-and-shoulders portrait created using the mountain and ski-slope poses.

The standing C and C pose.

able pose for the boy, it has a strong triangular base, and it can yield an excellent head and shoulders pose without using obtrusive posing devices.

The Standing C and C. Combining these effective standing poses produces a very pleasing and well-balanced couple image. Positioning both subjects in a C pose gives the portrait a very contemporary attitude.

The standing C and S pose—here, with the guy in a leaning pose.

A head-and-shoulders variation of the leaning pose with a warm look.

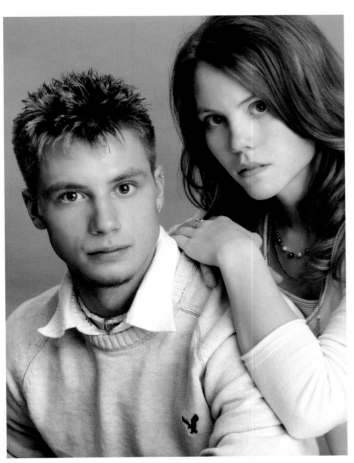

The Leaning C and S. The guy remains in a C pose (here, a leaning pose), while the girl switches to an S pose. The look is more graceful and shows a closer bond between the two.

The Lean (Head-and-Shoulders Version). Again, using a pose that the boy is comfortable with and then adding his girlfriend is an easy and very pleasing combination. In this head-shoulders-portrait, tipping the heads toward each other creates a warm look.

The Head and Shoulders (Version 2). Place the senior boy in a masculine leaning C pose and tuck the senior girl into his shoulder. A traditional guideline for head-and-shoulders portraits of couples is to align the lips of the taller subject (usually the male) with the eyes of the shorter subject (usually the female). Although this not always possible, doing so usually creates a very pleasing, balanced portrait.

LEFT—*Another head-and-shoulders variation based on the masculine C pose.* BELOW—*Don't let traditions limit your posing when working with couples—try something unexpected!*

5. Indoor Sessions

The Basic Yearbook Session

How It Used to Be. Let's face it, the image many people will be remembered by is their senior yearbook portrait. For years, this has been the only reason hundreds of senior boys have been dragged by their mothers to a professional photographer. Nobody wanted to be left out of the yearbook. It was a disgrace to have your name at the end of the senior section listed under "no photograph available"—or worse, to have a blank space with your name and "no photo available" written under it. It was also a disgrace to your family to wear anything but your Sunday best and a perfect hairdo.

How it is Today. My how times have changed! In some areas of the country, "cool" now means *not* having your portrait in the yearbook—and to have that dreaded "no photograph available" next to your name is even more cool. Seniors are having cell-phone picture parties they take each others' senior portraits. Color corrections and retouching are either not done at all or done poorly in Photoshop Elements. Essentially, quality is not part of the program.

Don't Take it Lightly. Surprisingly, the yearbook portrait is the image that is most easily overlooked; as professional photographers, we tend to concentrate on showing seniors the cool things we can do for them *other than* the traditional yearbook poses. Don't make this mistake and bypass the importance of the yearbook portrait. It is a great opportunity to show the parents and the public how great a professional portrait looks in the yearbook—and whether they admit it or not, seniors want to look good. When they look at last year's book and notice that some students just stand out because of the quality of their yearbook portrait, it gets them thinking, "I bet that photographer can make me look real cool."

What Guys Want. You're not going to see many suits and ties on the guys for these portraits—and maybe not even clean-shaven faces—but with good lighting you can make them look really great. You have only the head & shoulders to work with, but the attitude and pose you use can bring out a real macho image. (And, no, they don't have to smile.)

What Girls Want. Girls want to look pretty but with some sensuality. They see the images of young females on television and in magazines, and these portray the young ladies more sexually than their parents are often prepared accept. However, even parents are getting conditioned to the "hot look"—the constant, "Dad, Mom, everybody's dressing this way!" Don't try to mimic the sensuality level of a television persona's portrait, though. Instead, try to find a balance—a version of sensuous-*like*. This can be done by concentrating on the expression, the eyes, and the hair in closeup shots. By moving in close to the face you don't show any suggestive body postures that might alarm Dad. Mix in some happy, toothy smiles (the kind Grandma

ABOVE AND FACING PAGE—*Girls want to look pretty but with a little bit of sensuality.*

will like) and you're all set. Let the senior and parents decide which image should go to the yearbook editor—you're out of the cycle.

Show Their Personality. The modern yearbook advisor no longer demands a cookie-cutter identical head-and-shoulders style for their yearbook images. Don't be afraid to let the senior's personality and style show in their yearbook pose.

What Else Can We Do at the Indoor Session?

One of the most valuable entities of any photography book is its use as an idea source. Therefore, we've put together a collection of images with a variety of common themes—ideas you can use to inspire your in-studio sessions with senior-portrait clients. These are profitable (and fun) sessions for the photographer, so let your imagination run wild!

Collections. One of the things that has always been a draw for our studio are the "collection" pictures we do for seniors. Over the years, we've photographed a variety of things that seniors collect. Most common are collections of athletic uniforms, stuffed animals, NASCAR memorabilia, and hunting/fishing trophies. These have become so popular we have had to limit the senior to one collection per session. If the senior has more than one collection, we have to schedule additional time and charge a nominal fee in addition to the regular session fee.

A Special Outfit. Many seniors have a special outfit that was important in creating a memory for them. It many be a prom dress or a costume from a part they played in a performance. It's sort of playing dress-up for big kids—but provides a special memory, none the less.

Hats. When doing a senior session, the need to make it fun cannot be overemphasized. We keep a collection of hats in our prop area in plain view, and seniors will often pick one out and start spontaneously posing. When this happens, we just expand on the situation in a fun way.

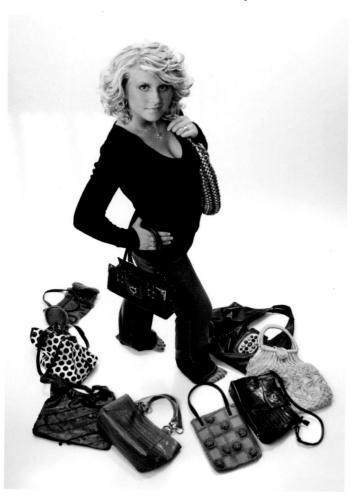

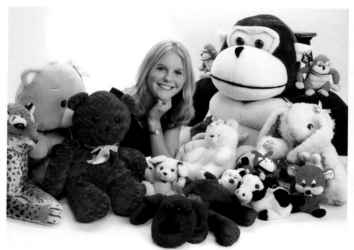

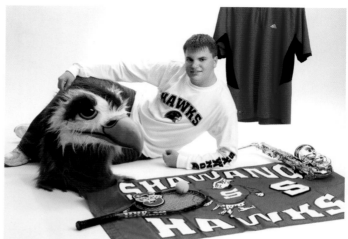

ABOVE—Portraits featuring collections are very popular. **FACING PAGE**—*Hats can inspire some fun studio portraits. Sometimes being photographed in a special outfit can also create a special memory.*

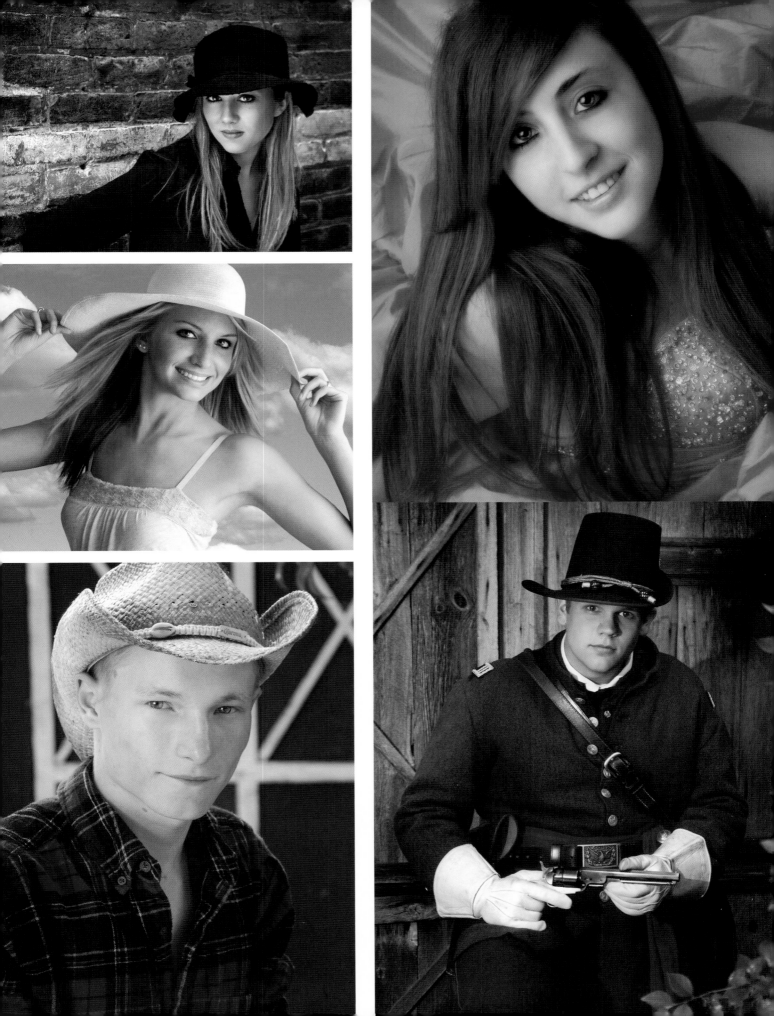

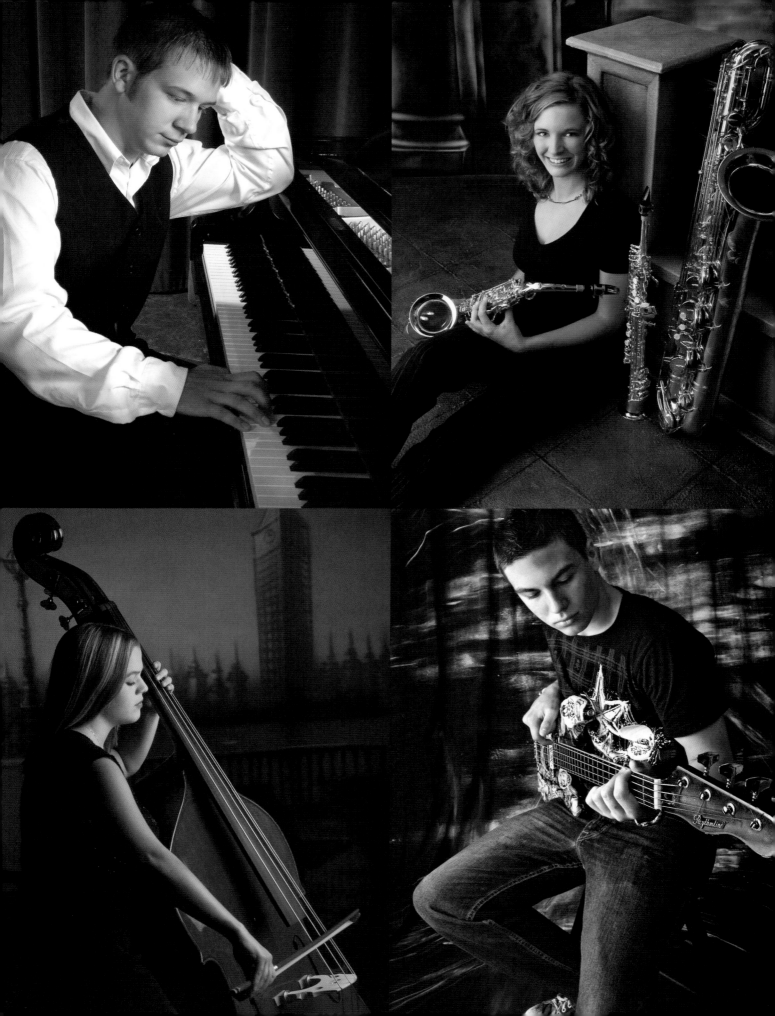

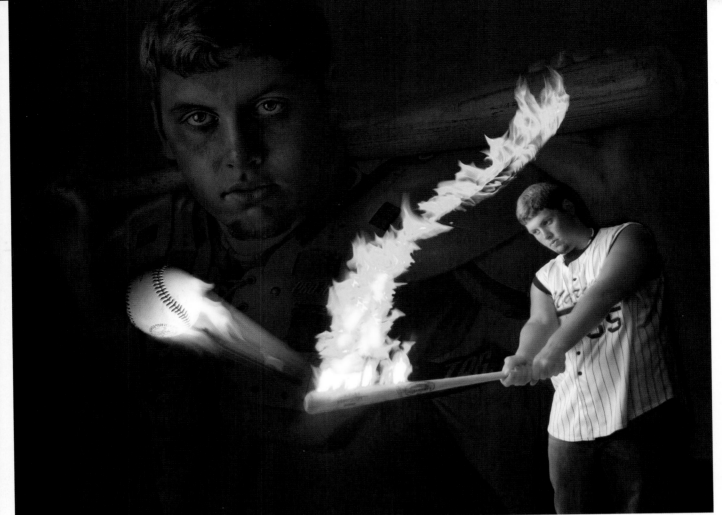

FACING PAGE—*Music is a big part of many seniors' lives.* ABOVE AND RIGHT—*Actual flames can be created on the set, or you can add them in Photoshop.*

Flames. Adding flames to an object is a popular request. We have done this with the help of Photoshop, but the effect is not quite as believable as an actual flame in the object itself. Before the popularity of digital cameras we created this look with real flames produced by rubber cement spread on the object (this is described in detail on page 40). For this reason we still sometimes utilize the actual flame technique. If you decide to try this, use extreme caution (see the safety notes on page 40) and make sure you have a fire extinguisher and fire blanket close at hand.

Musical Instruments. Another common theme is the senior with their favorite instrument(s). Guitars are the most common, but we see everything from huge drum sets to tiny piccolos. The number of requests we received for pictures with a grand piano has led us to set up a special "piano day." This involves renting the high school auditorium stage and their large grand piano at which seniors can

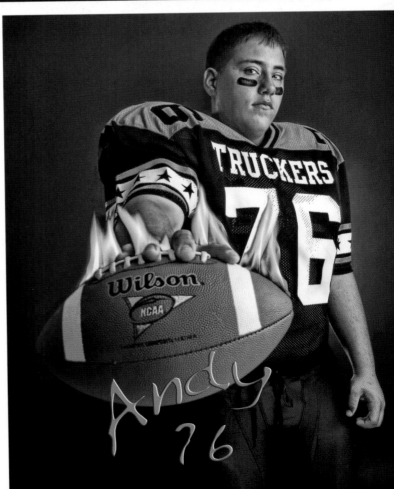

pose. In schools that have very active band-parent groups, this is a popular session. This session is available only after the initial studio session is completed and a minimum 11x14-inch print size is required from the session.

High-Key Portraits. Using an all-white, high-key background is a style that comes and goes in photography. For high school senior, though, high-key photography has a youthful presence that works well for a lot of looks. It is especially useful for sports setups. For more on our high-key setup, see page 34.

Blowing Hair. Blowing hair is a fun style for girls with long, flowing hair. It makes them feel like they're on a model shoot for a magazine ad. A portable hair dryer will work to get the hair moving, but a small contractor's portable fan works even better. We found one made by Stanley at Home Depot.

FACING PAGE—*High-key portraits have a youthful feel that suits seniors.* BELOW—*Blowing hair gives the image a fashion edge many girls like.* RIGHT (TOP AND BOTTOM)—*Is your subject an athlete? Show off their accomplishments in their portraits.*

Sports. Over half of our seniors are involved in either individual or group sports. If you know from the pre-session get-together (or from their personal inquiry questionnaires) that they're having a successful season, it becomes a natural topic of conversation. As a rule, seniors who are involved in sports are more outgoing and easier to photograph.

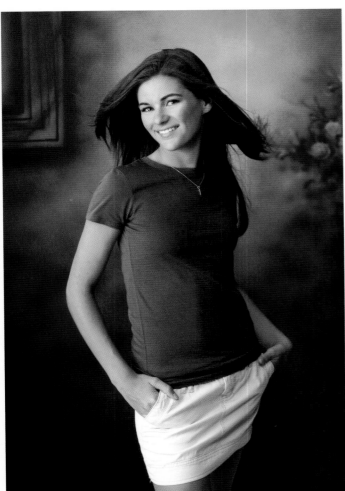

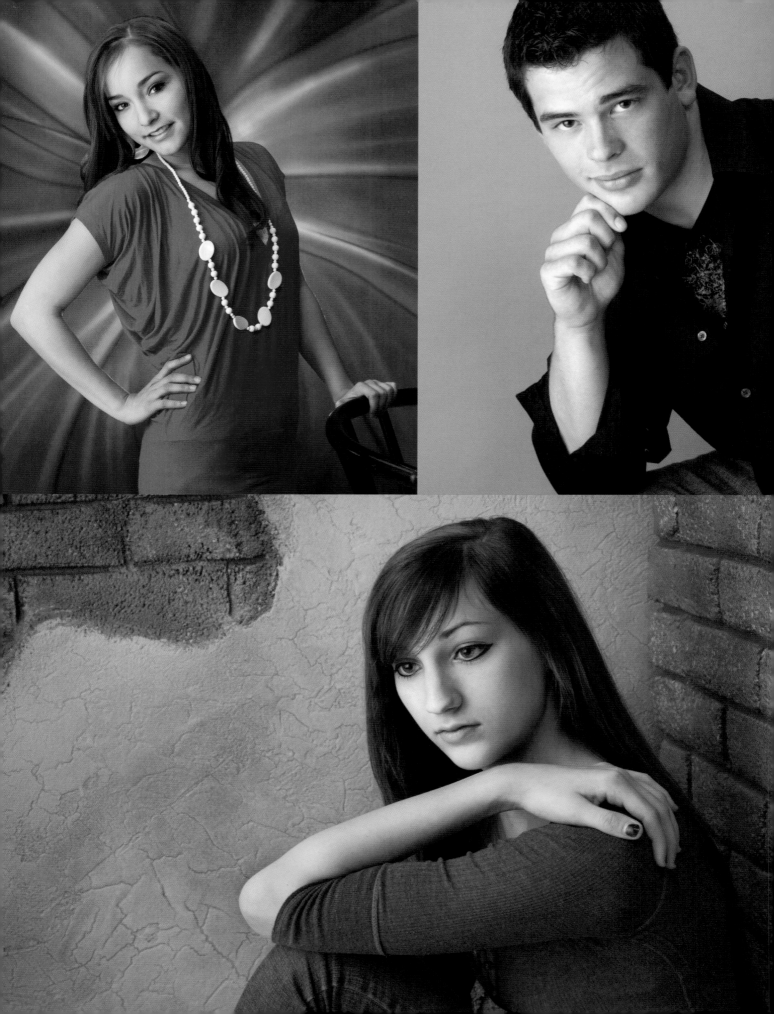

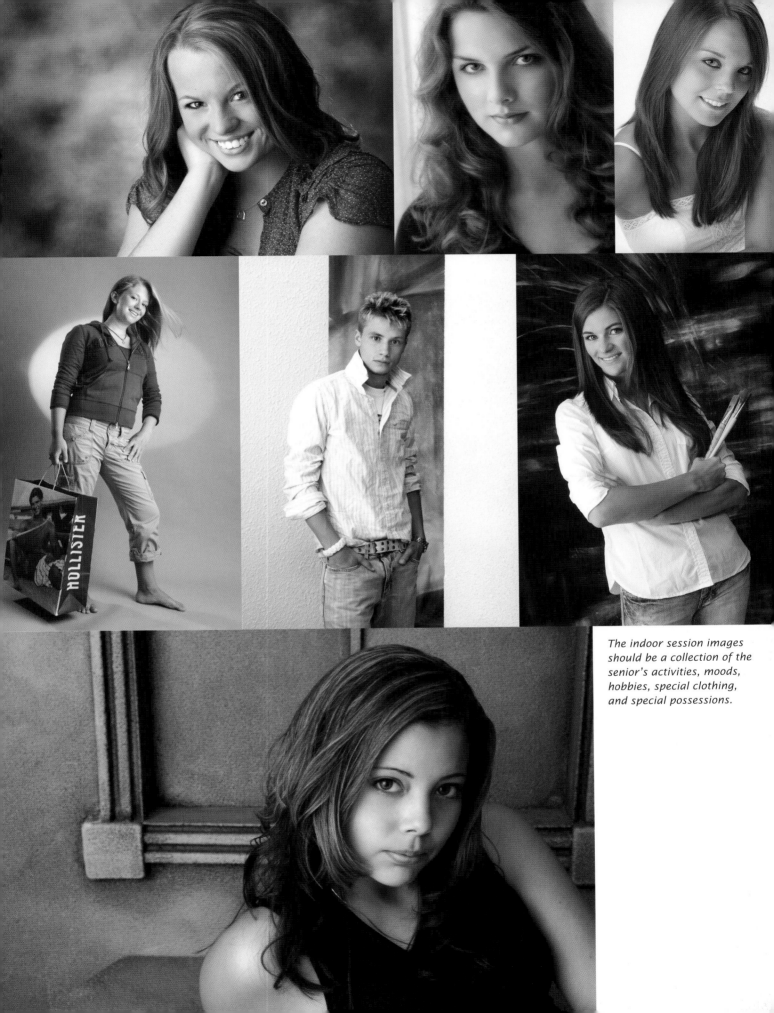

The indoor session images should be a collection of the senior's activities, moods, hobbies, special clothing, and special possessions.

6. Outdoor Sessions

By this time, you should have created numerous interesting images of your senior-portrait client in an indoor environment. Now, it's time to escape to the outdoors—time to think big and free.

The Benefits of Outdoor Photography

If you have a big lot, build large permanent sets with high school seniors and family groups in mind. If you do not have the space, find someone who does and rent it.

The investment in an outdoor photography area is worthwhile for a variety of reasons. First, it will separate you from the competition—particularly the big chain-store photography studios and the contract photography companies. Even competitors who also have outdoor facilities

will be different, because no two studio locations can be exactly alike.

Second, seniors photographed out of doors will usually place larger orders and choose larger-sized images. Because outside the environment is an important aspect of the photograph, it must be shown as part of the image, and causes the subject to be smaller in the frame. As a result a larger sized image, like a wall portrait, is necessary to display the senior's likeness. (*Note:* As mentioned below and covered in more detail on pages 71–73, the same principle holds true when photographing seniors with large props, like cars or horses.)

Third, the outdoor studio allows for seniors to bring large props (like cars) and large animals (like horses). We annually have rural seniors bring their prize-winning livestock to be part of their senior session. With large props come larger-than-normal orders.

Finally, working outside puts many subjects more at ease. Inside the studio, the props and high-powered strobe lights can be intimidating. This makes it harder to get shy or reserved subjects to relax and look like they're enjoying the session. For this type of senior, outdoor photography is often the answer; it helps break through the nervous tension. Senior guys especially tend to be much more willing

Soing outdoor sessions helps you stand out from the competition.

The outdoor studio allows for seniors to bring large props—and utilizing the fall foliage adds variety to your images.

A wide variety of backgrounds can be utilized.

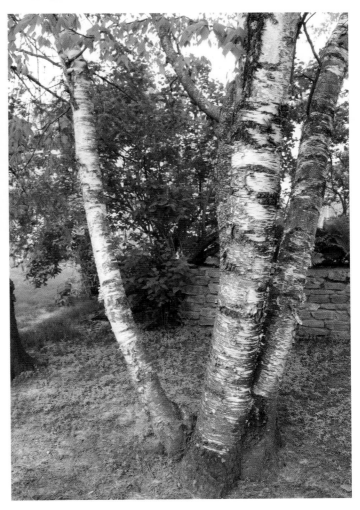

to have their portraits done when photographed with their wheels, a favorite animal, or in sports gear. Girls are willing to let their hair blow in the wind, go barefoot in a prom dress, or swirl in a peasant skirt. Both genders immediately show a much more relaxed and fun mood out of doors.

Planning an Outdoor Photography Area

In constructing your outdoor photography area, spending time in careful planning before starting construction is important. Remember, you are designing a *photography set* so forget about hiring a formal landscaper. Also, be sure to check the local zoning regulations and obtain any necessary permits before you start. Don't start building something you'll be forced to remove later.

Look for Great Light and Versatility. Try to have key sets facing north with open sky. Also, keep in mind that the one set's background can also be the back side of another set. This helps maximize the variety you can create within your space. Using a zig-zag style of fencing can also be helpful, because it forms a variety of little nooks that can be designed as individual sets. The fencing can be alternating wood, wire or vegetation to create variety.

Control the Overhead Light. If you have mature trees on your lot, use them as a canopy. If you do not, build solid overhangs of wood or fiberglass to block the overhead light (allowing shooting throughout the day). Even suspending rip-stop nylon or shade cloth on wires will help

Ask the Neighbors

Because we are friendly and considerate with our neighbors, some have allowed us to use their backyards. Two of our neighbors are ladies who love flower gardens—each year, they grow lovely perennial and annual flower beds that always have something in bloom. Their arches and wooden-rail fences work wonderfully for portraiture, and they both seem honored to allow us to photograph senior girls in pretty dresses in their yards.

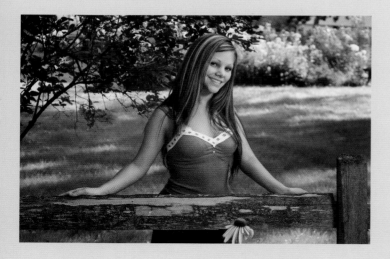

control the amount of overhead light. (*Note:* We've constructed an overhead mobile scrim on wheels called our Mobile Cloud, which gives light control wherever we don't have trees or building overhangs. For more on this, see page 74.)

Get the Most from the Foliage. When planting your area, choose plants with different-colored foliage to maximize the variety you can achieve. Foliage that changes through the seasons also gives backgrounds a dynamic look in color and shape.

Take Your Time. Don't feel you have to have your area filled with sets the first year. Adding one or two permanent sets each senior season keeps the expense manageable and gives you and the seniors something to be excited about each new season. Most photographers start with some type of old barn set or arch area. One by one, a pool, a gazebo, bridges, ponds, waterfalls, flower beds, iron gates will follow. To keep things fresh, some of our sets are taken down after a couple of years and replaced with new ones.

Consider the Neighbors. Whatever you decide to build in your backyard, remember to consider the neighbors. Don't create anything they consider to be an eyesore or that will bring down property values. We've grown a border of evergreens and high, neatly trimmed shrubs that hide our photographic landscaping.

Our Most Successful Outdoor Sets

Let's take a look at some of the most popular and successful sets in our photo park.

The Barn. The barn set was our first and is still used today. It was constructed of lumber from an old farm building that was torn down. A pair of Dutch doors create varying posing levels. Several windows also provide posing opportunities at different times of the day. Overhead, translucent roofing fills the inside of the barn with natural light, providing separation and excellent hair light. Celotex insulation boards placed on hidden walls also make great reflectors to fill in any dark shadows. After the initial build, we added a rustic old wooden wall on either side of the barn to expand the posing area. The space is now large enough to pose seniors with horses. The wall can also serve as a trophy wall for successful young hunters.

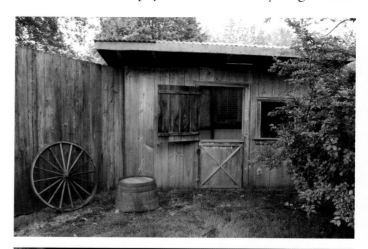

The barn set was our first build and remains popular.

The Old Fence Rail. To be successful, a set doesn't have to be large or expensive. Our most requested individual set is a simple split rail fence and wood posts with an overhead tree canopy. Having a rail or post to lean on

makes the subject feel secure and is a great starting point in our outdoor sessions. Something about the set relaxes the most timid senior.

Trees. Trees are great spots for senior poses. If you are fortunate enough to have mature trees, use them. The bark will have a variety of textures and colors that varies according to the time of day. Simply looking at the trees also gives you an easy way to determine lighting ratios. Step back and study how the light is causing highlights and shadows on the bark, creating texture and definition. It will do the same in creating definition in the senior's face when they are placed next to the tree. If you are not sure where to place the model, have them pose with their back to the tree. You'll see when they are in the best position.

The Covered Grape Arbor. When eating at a fine outdoor garden restaurant, we noticed how great everyone looked in the light. It was the location that faced the open northern sky and the canopy of grape vines, eliminating overhead light, that created the great portrait light. Some old barn beams, a translucent fiberglass roof, and some grapevine plants have provided our photo park with a similar set. With the addition of a rope swing on one end, a graffiti wall on the back side, and a group of evergreens on the opposite, this set is actually four completely different sets—and everyone wants an image taken from one of the multitude of angles possible under the grape arbor set. When the girls see the swing, this is immediately a must-have pose as well.

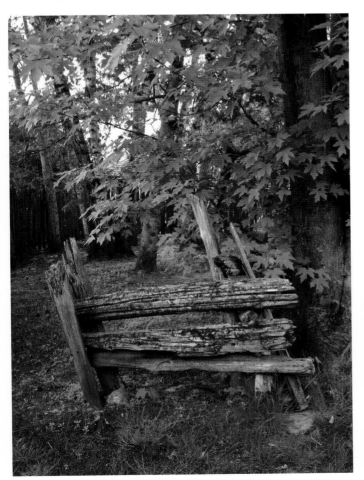

The fence rail set.

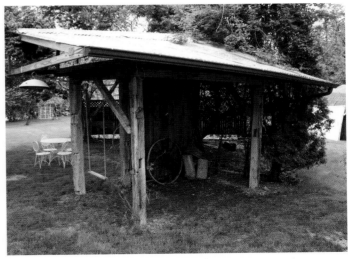

The grape arbor offers a multitude of shooting angles.

Mature trees create excellent portrait sets.

Gazebos. Gazebos are a showy set that add to the overall allure of an outdoor photo park. With their (usually) hexagonal shape, they also allow a variety of shooting directions. Surrounded by flower beds, it is an easy choice for girls in party and prom dresses. Still, whether or not to build a gazebo is something you should consider carefully. In spite of the photo opportunities that gazebos offer, they are expensive and require a large amount of space. Additionally, with six directions from which to photograph, you will require six rather large backgrounds. A beautiful

gazebo portrait is less desirable when the neighbor's ugly garage is in the background or when cars can be seen passing by on the street behind.

Ponds and Waterfalls. Ponds and waterfalls are always useful types of sets. Besides senior photography, they are popular for photography of small children fishing or sail-

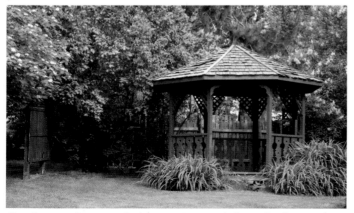

Gazebos can be versatile but require ample large backgrounds to make them work effectively.

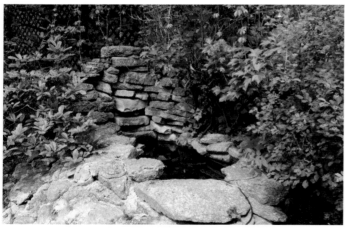

Water features are a worthwhile investment for your outdoor shooting area.

This locker-room set is a popular choice—especially for athletes.

ing small sailboats. The combination of angles and backgrounds that are possible make small ponds a worthwhile investment in space and money. We have several ponds that vary in size and plantings. Some were created simply by burying a kids' plastic swimming pool, then adding water lilies and colorful goldfish. (*Note:* When installing these small ponds, employ some type of filtration and aeration system or they will soon become smelly eyesores rather than photographic sets!) To some of our water features, we've also added bridges and waterfalls. One pond has a faux bridge that can be used with one of four sets of bridge railings, giving it a variety of looks.

The Locker Room. When an area high school was remodeling the boys' locker room, they removed the old lockers and replaced them with a larger style. We obtained a set, removed the front door section, and attached it to our garage wall. We added a plank bench to make a realistic locker-room set. It has become a favorite set among athletes.

The Artist's Tent

A situation that produced beautiful portrait light revealed itself at an outdoor art show. An old artist with a classic white Santa Claus beard caught my eye. His face, hair, and beard were illuminated with the classic Rembrandt style of lighting. What made the light on his face so perfect was the white artist's tent overhead. It was a large, diffused source of light—perfect for portrait photography. We immediately ordered a white 10x10-foot artist's tent, which is now used to photograph senior portraits outdoors. We simply move it around the backyard to best utilize the di-

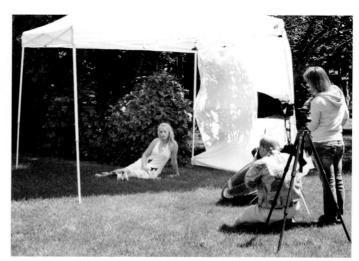

An artist's tent provides great outdoor lighting (and shelter on rainy days).

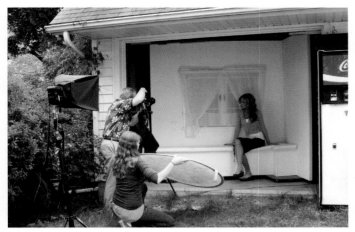

A portable high-key set lets seniors who opt for only an outdoor session get images with this popular look.

rection of sunlight according to the time of day. On rainy days, it serves as a shelter as well as an outdoor studio location.

A Portable High-Key Set

A unique set is our outdoor high-key set. For those seniors who want only an outdoor sitting but still would like some high-key or glamour shots, we built a special high-key window set in our garage. This is on wheels and can be rolled in or out according to the amount of daylight, providing an adjustable level of natural fill light. A small portable strobe then acts as our main light. Another small strobe is placed behind the window to give the illusion of daylight coming through it. This light can be adjusted to function as an edge light or, alternately, to replace the main light.

Other Moveable Sets and Props

Outside locations change throughout the length of the senior season. As a result, images photographed at a site in May will be completely different looking than those photographed at the same location in August or September. After the Fourth of July, we see a noticeable change in the color of light and the angle of the overhead light, so we use a variety of sets and props that can be moved as the seasons change. As necessary, we simply reposition them to achieve the best light quality and use the most favorable backgrounds. Examples of these sets and props are shown above (right).

Personalize with Props

Let the senior bring the props for the outdoor session and encourage big items like cars, trucks, boats, motorcycles,

Moveable sets and props allow you to take advantage of the best lighting and backdrops—even as they change over the course of the year.

ATVs, and even large animals—all things that big-box stores (and most of your competitors) cannot photograph indoors.

Cars, Trucks, and Other Vehicles. A universal theme is wheels. Seniors work for a few reasons in high school, and a big one is being able to buy a vehicle. Because a vehicle, with its special responsibilities, is an important symbol of a senior reaching the age of maturity, it's also a popular prop for the senior's photo session. We see cars, trucks, ATV's, motorcycles, scooters, and bikes of all ages and in all conditions.

For some senior boys, including their car is the only reason they even consider having senior pictures taken. So, in your senior advertising, be sure to stress you take "wheels" pictures. Even if you don't have a studio or photo park, figure out how to offer pictures in the driveway if necessary. To book and secure seniors early, we also offer a day of snowmobile sessions in January or February. This is free as part of their regular summer session—a reward for early

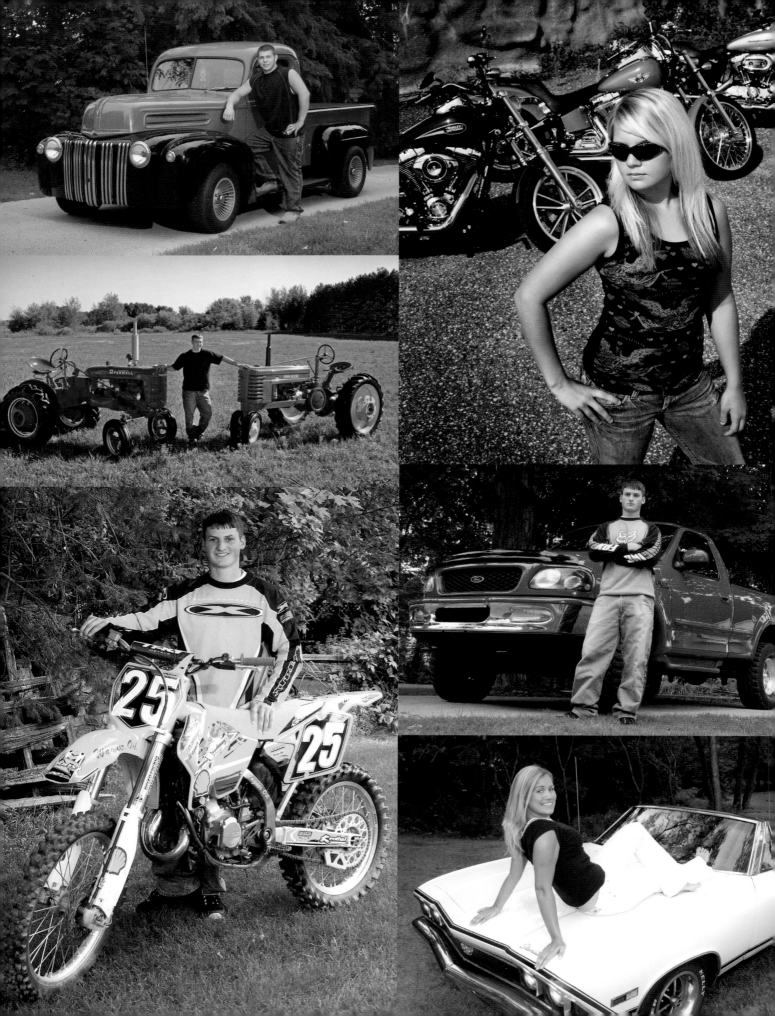

FACING PAGE—*Seniors love their wheels. Including them makes a portrait that is truly personalized.* ABOVE AND RIGHT—*Pets are a beloved part of many families.*

scheduling. In this way, we have seniors booked long before they are deluged with senior mailings in the spring.

Pets. Pets are a beloved part of many families and must be part of any family portraits. As a result, we see a family pet with every three to four seniors we photograph. In a typical summer, dogs and cats are the most common, but we see a variety of animals, like ferrets, snakes, birds, farm animals, and reptiles. (We even hear as the reason they did not pick a certain image that, "It was not Fido's normal smile!")

The most difficult group to please are horse owners. The senior may be beautiful and posed well, but if the horse's ears are not forward, the image is rejected. Fortunately, we now have Photoshop to straighten top lines, make horse ears even, and polish hoofs.

We include pets with the senior poses for no extra charge—except horses. Because of the extra time and attention required to detail horses, we charge a separate session time when horses are included.

Interests and Hobbies. In our part of the country, hunting and fishing are part of becoming an adult for senior guys—and now for more and more girls, as well. To showcase this, we have constructed an old hunting shack and trophy wall where seniors can display their trophy game mounts. We also provide a nearby tree stand where they can pose with their guns and bows, dressed in their hunting gear. This type of theme will not be suitable for all parts of the country—it may even be banned in some—

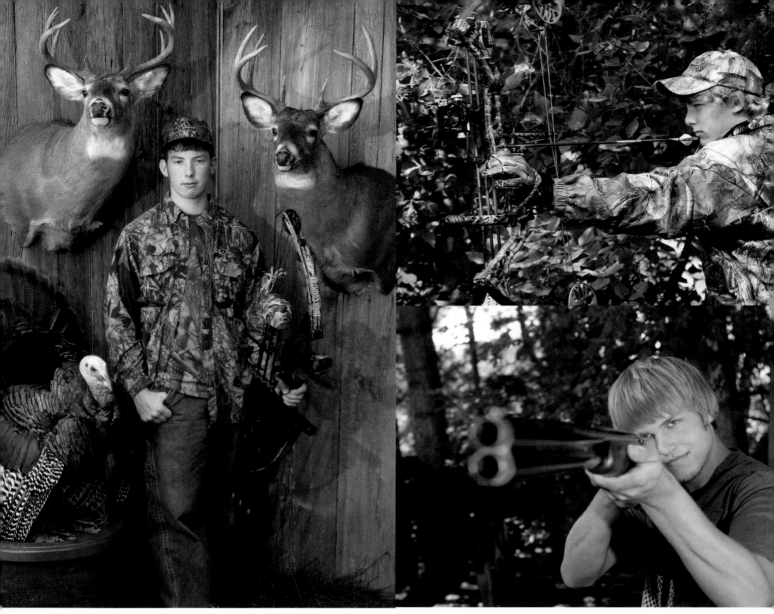

Hunting and fishing are popular in our region. What activities are seniors involved with in your area? How can you feature these in their images?

but in our area it is very much a part of their senior lifestyle. I've included this as an example of how photographers must understand the activities in which seniors participate. You must be ready to accommodate local tastes and traditions if you are going to be the senior's studio of choice.

The Right Equipment is Just as Important Outdoors

The Mobile Cloud. One piece of equipment we have designed and built is what we call our Mobile Cloud. It's a 6x12-foot translucent scrim built on a rolling platform. Using this allows us to photograph from sunrise to sunset. It works as a sun shade midday, a portable roof on rainy days, and a large reflector panel on cloudy days. Use

of the Mobile Cloud has allowed us to book senior sessions every hour of the day without having to stop for the middle portion of the day. It has brought us many dollars in sessions we would have had to pass on before developing this tool.

Camera and Flash Equipment. When photographing outdoors, we use the same camera systems we use indoors, with exception of the flash system. Our favorite lens is the Canon L series 24–105mm zoom.

Outdoors, we like to shoot at the widest aperture of the lens to blur the background. To do this, we utilize a carbon tripod made by Bogen with a Gitzo head and a small portable flash unit controlled by a remote PocketWizard slave. This flash is not intended to light the subject, only

to put a twinkle in their eyes, soften any hard facial shadows, and to color correct any unwanted reflected color casts. If this fill flash is noticeable in the image, it's too much. When starting the session, we meter the ambient light and the flash separately to determine the needed ratio of flash to ambient light. Setting the flash power about a stop lower than the ambient light gives the adequate amount of fill.

Reflectors. In extreme shade, we often add light to the shadow side of the face with a reflector disc. Sometimes, strong overhead light also requires the use of a black disc above the subject to subtract unwanted light. If you are having a problem with dark eye shadows (we call them "raccoon eyes"), this overhead gobo may be your solution.

The Mobile Cloud makes photography possible throughout the day.

Reflectors provide fill when working in extreme shade.

Action Shots

When you're out of doors, try for images with animation. Put the gal on a swing or have the guy kicking the soccer ball. Keeping the senior's attention more on the activity and less on the camera will result in more natural and personal images.

If a parent or friend is along, let them get involved by holding the disc; it makes them feel like they're helping create the image. Otherwise, have your assistant handle the duty.

But What if it Rains?

The most asked question when seniors are scheduling outdoor sessions is, "What do we do if it rains?" Our photo park is constructed with 3- to 4-foot overhangs on all the buildings. This allows the senior to be placed under the overhang and be photographed in spite of any precipitation. The senior is then moved from location to location with the help of our assistant and large golf umbrellas. Where there is no roof overhang, the Mobile Cloud (see page 74) comes to the rescue and serves as a roof over the senior. The photographer is covered by a large umbrella, as well, keeping him and the cameras dry.

The only time shooting is suspended is for periods of intense downpours or threats of lighting. Summer storms are usually short lived in the Midwest, and by the time the inside session is completed the storm has usually passed. In the past four years, we have not had to reschedule an outdoor session because of weather. In fact, some of the

On rainy days, umbrellas, the Mobile Cloud, and ample overhangs on the sets make it possible to keep shooting.

most pleasing skin color and beautiful background greenery have come on not-so-great weather days.

What About Bright Sun?

Photographing seniors in the sun can be difficult, but when you're a professional photographer you have to be able to adapt to any conditions. When possible, choose a site for the senior's portrait that faces north and has a natural overhead canopy of foliage. This is not always available or possible, though—and many times the senior has a favorite spot chosen or the parent will want a portrait shot in the same spot where an older sibling was photographed. When conditions like this make the location unsuitable for producing good portrait lighting, here's what we do:

1. We first look for a nearby site that is acceptable to the senior and has better light conditions.

Even on a bright day, look for nearby sites with better lighting.

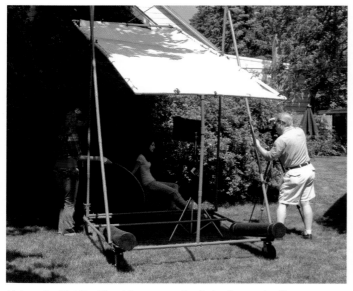

Using the Mobile Cloud improves the light dramatically.

2. If this is not possible, we bring in our Mobile Cloud (see page 74) to change the conditions. Moving in the Mobile Cloud provides a large scrim, for soft light even in horrendous light conditions.

3. The other option is to use building overhangs to create shade. This puts the camera in the bright sun, though, so you must be careful to provide suitable lens shading to prevent flare that degrades the image quality. If necessary, reflect light on to the subject and add a small fill flash to create a pleasing light ratio.

4. If you have (or are constructing) your own photographic park, design structures that are protected against bad weather and too much sun. Then you'll always have good options.

What About Overcast Days or Heavy Shade?

For the most natural looking light, we bring in the Mobile Cloud (see page 74) as a reflector. The scrim is set vertically and locked in position. We simply move the Mobile

These are the results using the Mobile Cloud as a scrim.

ABOVE AND RIGHT—*Overhangs block the overhead light, making it possible to work in bright sunlight.*

ABOVE AND RIGHT—*Sets can be designed to combat the problems of bad weather and bright sun.*

Cloud into a position where the overhead light hits the flat side of the panel, then angle the reflected soft light onto the senior. The amount and ratio of light can be easily viewed from the camera position. A light reading is taken from the specular highlights on the senior's face. Whether the light hitting the Mobile Cloud is filtered through the scrim or reflected off the white surface, the quality of light is excellent for portraiture.

When the Mobile Cloud is not available, a small flash and pop-up reflectors are used. Depending on the conditions, the flash may be used as either the main or the fill light. We prefer fill flash to be minimal (one stop below the ambient light) and use flash as the main light outdoors only in extreme conditions.

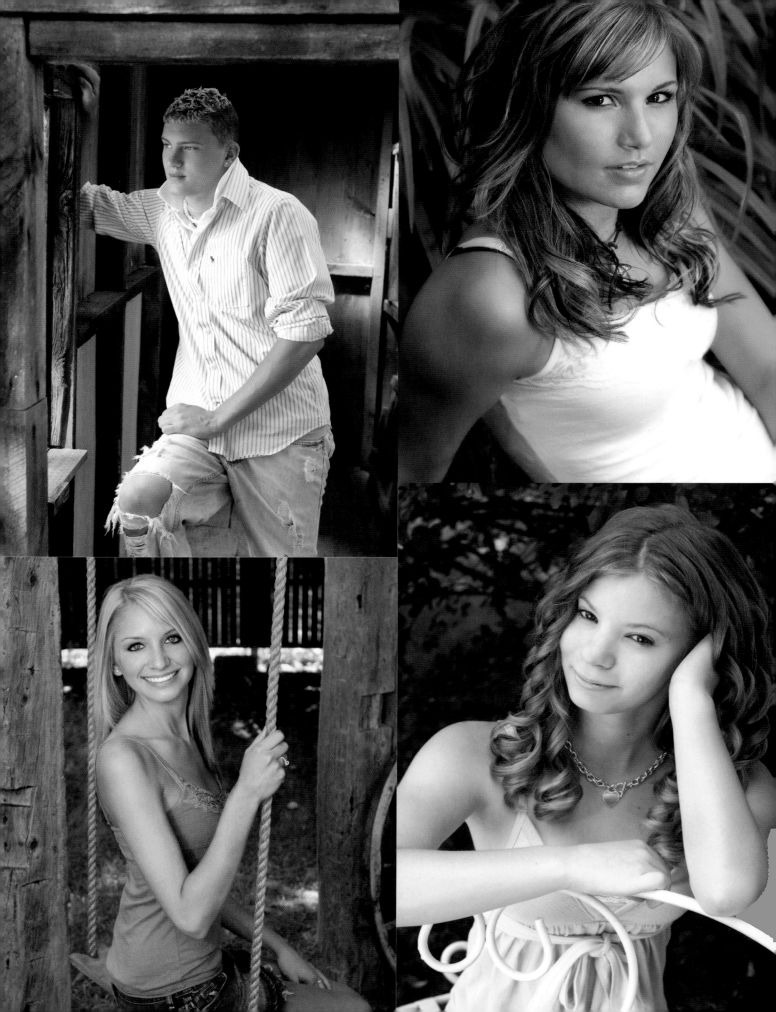

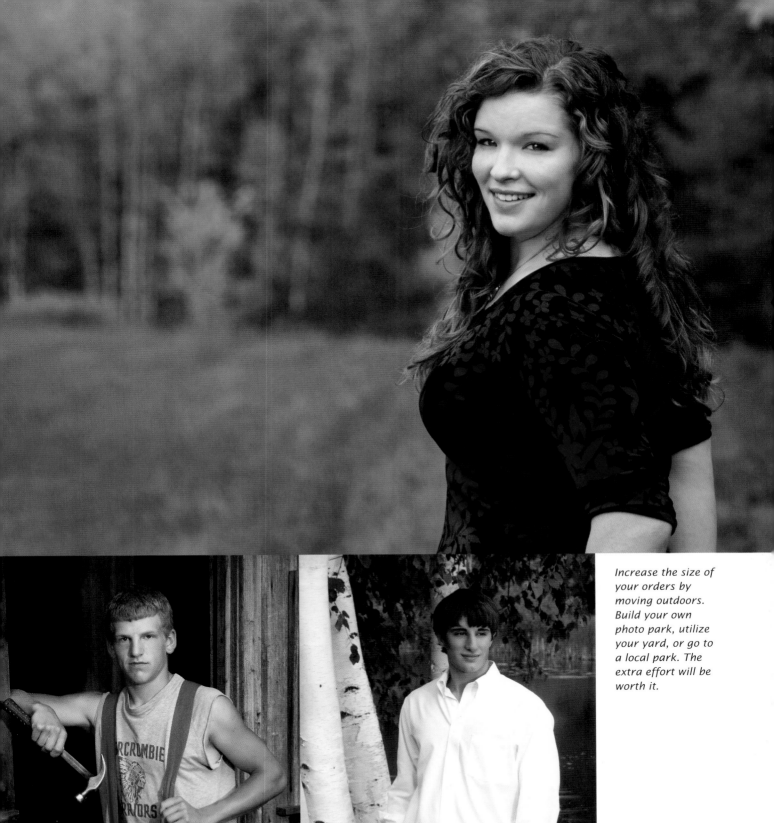

Increase the size of your orders by moving outdoors. Build your own photo park, utilize your yard, or go to a local park. The extra effort will be worth it.

7. Location Shoots

With the availability our of adjacent outdoor facilities, we are able to meet the needs of 95 percent of our senior clients. If a photography park isn't an option for your studio, you can still benefit from offering outdoor photography. Look around the neighborhood close to your studio for areas that provide good settings for senior portraits. Whenever possible, find a spot with overhead shade and open sky toward the north for ideal lighting. When you find such a spot, it can be used over and over from different angles and elevations giving the same site different appearances throughout the day.

Some subjects will still want to go to that "special spot." Through the years, we have learned to be careful about this request. Once, we tramped through a cedar swamp, swatting mosquitoes and carrying our gear, to an old run-down shack where the senior and his dog go duck hunting. Another trip described as "just down the road at my uncle's farm" took us on a 46-mile drive. Without some limits and careful planning, the session can easily turn into an "It's All About Me Session" to boost the senior's ego.

Planning and Preparation

If you are located near a large population of seniors, perhaps you can specialize in just doing these special seniors

RIGHT—*Look for contrasts when scouting your area for potential senior-portrait backgrounds.* BELOW—*Taking the senior guy to a gravel pit is a macho setting for him alone or with his wheels.*

who want only to be photographed on location. For the large majority of photographers, those of us who do not have the luxury of being able to select our senior clients, this is not an option.

Discuss Large Prints. When scheduling a location session, be certain to discuss the importance of showing the environment—that is the reason for making a special trip. There's nothing more frustrating than spending extra time and money to sell only a tight head-and-shoulders portrait. However, if the location is truly special to the client, you can take your time and create a very meaningful portrait and hopefully sell larger-than-normal portraits that show their special place.

Charge a Fee. Be sure to charge a fee large enough to make the session profitable. We use a separate agreement form for any special "safari shoot" that takes us to a specialized location, like the family's home. This specifies a minimum order size, a separate session fee and mileage charges, a time limit, and parental permission. Because of liability issues, we do not take subjects anywhere in our company vehicle. We follow them or meet them at a specific location.

In reality we make a much better profit from two regular sittings at the studio than on any safari. However, these sessions are a break from routine, generate positive word-of-mouth, and create neat images for our brochures.

Public Parks

Use the public parks in your area. You're a taxpayer, use your portion of the resources your dollars pay for—just check with city hall for any special restrictions or permits that may be needed before you start photographing.

Urban Scenes

Look for contrasts, like young senior *vs.* old building. Peeling paint and broken concrete are great backgrounds. A short walk from our studio is an old building that has been in the process of being torn down for a couple of years. We have produced numerous award-winning senior portraits there (and we hope they never complete the demolition process!).

Rural Areas

Rural students are proud of their environment and feel comfortable having some of their senior portraits done at a rural location. What we did not expect when we started

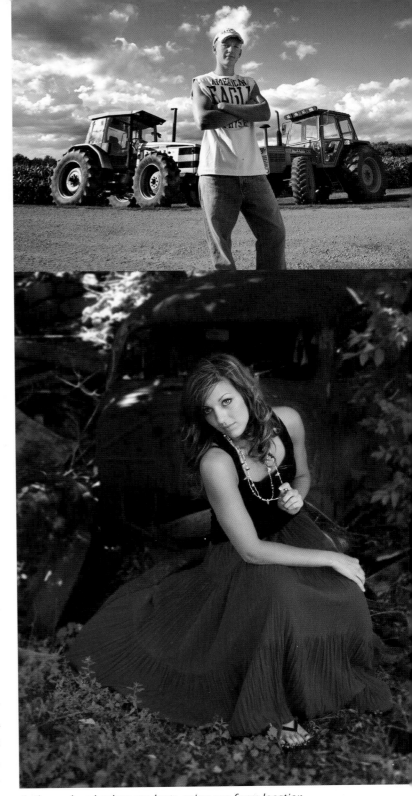

Both rural and urban students enjoy our farm location.

offering these sessions, however, was the number of requests by urban students to have their outdoor portraits taken on a farm. For a more controlled safari style, we now offer an environmental shoot on our farm. We have 84 acres of woods, ponds, streams, and ATV trails located fif-

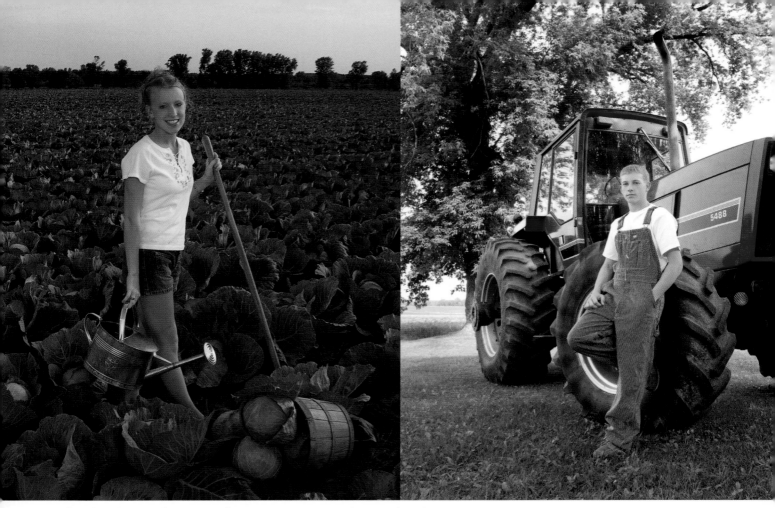

There's no limit to the variety of images you can create in a rural setting.

teen minutes from the studio. Here, the senior can bring his car, truck, dirt bike, etc. for the action shots. Or the senior can choose a low-energy activity like fishing, walking the trails, sitting on a pier, or relaxing in the fall colored leaves.

The introduction to this area usually leads to the booking of family portraits by the mother. We let them enjoy the location, particularly in the fall. They can hike, pick apples, fish etc. Best of all it's a great marketing tool in the positive word-of-mouth it generates.

Five Keys to Great Outdoor and Location Sessions

Identify the Customers' Wants. Although the "serving a need" business can be profitable and pay some bills, we are principally in the "want" business. Portraiture is mostly a luxury item, and we need people to truly want our products. A want comes from the heart, and if we can satisfy their want we can establish a long-term bond with the client, enhance positive word-of-mouth, and build a loyal customer base.

Remember, the session is about the client and what they want. It is your job to get to know them, reveal their wants, and do your best to deliver fine portraits that they will enjoy for many years. As a creative professional, it is easy to get caught up in new surroundings while photographing on location. When you go to the senior's home, farm, special place downtown, etc.; you may be introduced to new elements: architecture, colors, design, props, etc. and be like a kid in a candy store. You may loose focus on the job at hand and begin photographing scenes—forgetting the subject and what makes the location meaningful to them.

Of course, you'll find that the senior and their parents may not know what they really want besides "something different." In that case, survey their location, select your favorite spots, and do your best. Listen for clues about their favorites and least favorites, then adjust accordingly.

Respect Them and Their Space. Although you are being commissioned to create an art piece, that doesn't give you free reign to dictate the session. Again, they hired

you to come to their location for a reason. Don't waste their time and money by doing work to enhance your portfolio. Most importantly, if the location is their property, respect it and be tasteful. Don't barge into their bedrooms, bathrooms, etc. Go where they ask you to go first, and ask permission to do otherwise. Once you have done what they expected, feel free to experiment—but always be courteous and professional.

Create, Don't Chase. Over the past few decades, a new style of portraiture has evolved called photojournalistic portraiture. Done properly, it can be very powerful. Unfortunately, there are only a few that have the skills to execute this type of photography. An experienced photojournalist knows that rarely does a great image "just happen." "Candid" isn't just another word for "lucky." You need to be in the right place, at the right time, with the right equipment, with the right settings, and be prepared to capture the image when it happens. You must master the entire gamut of photographic skills to consistently produce quality images and justify your clients returning to you for repeat business. Simply grabbing a camera and chasing your subjects while taking thousands of images is not professional. Create portraits that tell thousands of words, don't just take thousands of worthless snapshots. "Machine gun" style photography is the work of paparazzi; it isn't photojournalism.

Analyze the Location. Location analysis is very important. You must do this first before setting up your camera, etc. Otherwise, you will risk needing to reset and re-create everything—or, worse, missing problems entirely and being surprised when you process your images later. Let's assume that your senior wants you to come to their home at the lake and you've determined that they want their portrait by the water. Turn on your artist eyes and survey the territory. Look for three key elements to help you choose a specific spot: scene brightness, composition/dynamics, and posing tools/levels.

Scene Brightness. Control of scene brightness is crucial while on location. Unbalanced scene brightness can cause severe exposure and contrast issues that will distract from your subject. To determine scene brightness, step back and see the entire scene that will be captured within the portrait, not just where the subject is placed. Try to meter the different zones to define the difference. A spotmeter can be particularly useful for this job. Be wary of scene elements that differ by more than two stops from the light

illuminating the subject. Unless you are striving for a graphic image, going beyond that point will risk loss of control of contrast and even detail in shadow and/or highlight areas.

Photographing along the water's edge presents a classic scene-brightness challenge. Typically, your first thought will be to put the subject near the water with the water behind them. However, water is a big reflector. Except in specific light conditions (or with a nearby opposite shoreline) the water will be much brighter than your subject—and it will be "nuclear bright" in the captured image. Only skillful use of artificial light and faster shutter speeds can make this configuration plausible. Instead, try to photograph along the shoreline, using the water as a light source instead of a background. Doing so will give more dimension to the contours of the senior's face and figure and will often make the water a more interesting part of the image. Instead of being a blown-out mass of white, now it will have more definition in the surface. Reflections of scenery along the shoreline (trees, etc.) may also enhance the image with color and natural details. Additionally, in dull light situations you will be amazed by the power of water as a reflector. Because of its size and reflectivity, it can provide a light source where there may seem to be none.

You can apply the water's edge example to other locations. In the country, it may be a brightly lit field that draws unneeded attention. In town, buildings with large windows (or that just reflect lots of light) can be a blessing or a curse—just like the water.

Working indoors requires the same analysis, as well. If you're using window light to illuminate your subject, be aware of overly dark background areas in your scene that don't receive the same amount of lighting as the subject. Much like photographing near water, photographing parallel to a window is often much more effective that photographing directly into it (use it as a light source, not a background).

Composition/Dynamics. Location portraiture is a great chance for you to use your compositional skills, because you have more than one subject matter. Besides the senior, the background and its major elements are another. Buildings, props, pets, etc., are potential others. Arranging them in an interesting and pleasing way is composition.

A dynamic senior portrait typically places emphasis on the subject and makes them the primary subject matter. The other subjects should then be carefully placed to en-

According to the Rule of Thirds, if you divide the image frame into thirds, vertically and horizontally, the four resulting intersections are powerful points to place your subject(s).

hance the overall image and tell something about the subject, while not being too distracting. Emphasis can be placed by several means:

Size—Getting in close to the senior will make them larger and more prominent.

Lighting—Illuminating the subject with significantly more or less light will draw attention to them.

Color—If your subject is wearing a color, or has a skin color, that contrasts with the scenery, they may become the focal point.

Artistic guidelines like the Rule of Thirds can also help you identify key locations in the frame for placing your primary and secondary subjects. According to the Rule of Thirds, if you divide the image frame into thirds, vertically and horizontally, the four resulting intersections are powerful points to place your subject(s).

Since we read from left to right, we are most comfortable with images where the primary subject falls on the right side of the frame (at either on the upper or lower

point). Our eye comes in from the left edge of the frame, flows through the image, rests at the primary subject for a moment, and then proceeds back through the image toward the left, briefly enjoying the other subject(s) along the way, and then begins again. This circular flow is what makes a piece of art dynamic and exciting.

However, this doesn't mean you can't break the rules! If you do, smash them! For example, place a tough guy or girl senior in his or her athletic jersey or leather jacket dead center in the frame (compositionally, the least graceful position) to add to his or her apparent intensity and toughness. *(Note:* Avoid placing your subjects in between the center and the power points. This will cause an uncomfortable lack of balance in the image.)

Posing Tools/Levels. Finally, think about what types of furniture and props work well for poses at your studio and then search for similar sized and shaped ones while on location. (Or, it may be possible to take chairs, benches, etc., with you to the location.) Most chairs for adults are approximately eighteen inches up to the seat, and are made for someone to sit erect with their legs bent. Depending upon the pose desired, look for available posing tools

(chairs, stumps, steps, boxes, etc.) at that height—or lower, which will encourage more dynamic leans.

Analyze the Lighting. Lighting analysis goes hand in hand with location analysis. The level of difficulty of lighting the senior subject will depend heavily upon how specific their wants are. Lighting a senior "downtown" will be easier than "in *this* alley, against *this* wall, from *this* angle." If they are very specific, you can't say "no" and just do something else—you may need to reschedule for a different time of day, or you'll need to put on your professional superhero cape and make it work. Professional fishing guides can't just say, "Sorry, it's too rainy today, the fish won't bite we'll just have to go to the restaurant to get a fish dinner tonight." They need to rely on their skills and experience to find a way to help their customers catch fish, regardless of the less-than-optimal conditions.

The Characteristics of Good Lighting on Location

Good lighting is a combination of three characteristics: intensity, quality, and direction.

Intensity. Light intensity is pretty straightforward, just like seasoning the perfect soup: either there's too little, too much, or it's just right. Too little and you'll have a tough time exposing the subject and scene and maintaining detail in the shadow areas and maintaining sharpness at low shutter speeds. Higher ISOs now available in digital capture and films may help provide faster shutter speeds, but may cause contrast and scene brightness problems. Too much light and you may find obtrusive hot lit areas of the image or that are too strong for the subject and cause blown-out flesh-tone highlights that lose detail and color accuracy. Gobos and screens can be used to block or diffuse strong lighting, but may not be able to control light in the entire scene. Also, bright light will usually yield small

As a professional photographer, you must use your skills and experience to create great images even in tricky lighting situations.

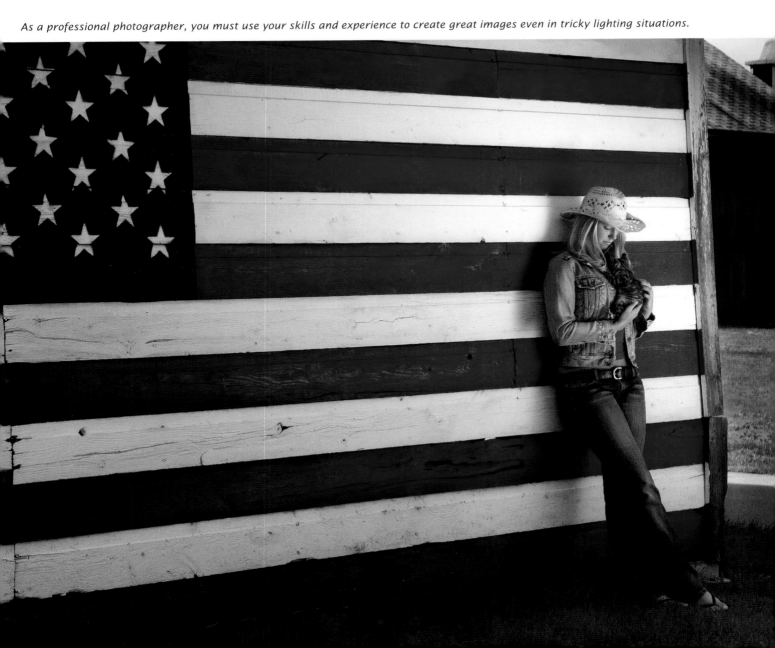

Soft light creates a gradual transition from highlight to shadow.

apertures and thus large depth of field which may cause overly sharp and distracting backgrounds. So, try to find existing light that is as close to "just right" as possible and work from there.

Quality. Light is either hard or soft. This can be determined by quickly studying the definition of the shadow edges. Hard light will show a defined edge, with the highlight and shadow sides sharply defined. Soft light shows a smooth gradation from highlight to shadow. Hard light conditions are not flattering, because hard light accentuates skin imperfections and tends to cause squinting. Only in specific cases (usually with professional models) is hard light used for portraiture. Soft light is more flattering; it hides more imperfections and renders more accurate flesh tones. This is why, when creating indoor portraits, north window light has always been the choice of the famous Dutch artists. The same is true for the photographers of today.

Direction. The direction of light is important for building dimension and contouring the senior's face and figure, which can enhance their positive features and hide their negatives. If you first identify the direction of the light, you can then pose the senior accordingly. Turning the senior's body away from the main light source and then turning their head back toward the main light source is an excellent technique for slimming the subject and maintaining maximum detail and color saturation in their outfit. Replicating traditional highlight to shadow ratios (3:1, 4:1, etc.) on location is an excellent way to create portraits that make the subjects look their best.

Leon Kennamer, an authority on environmental portraiture, taught us to study trees to determine the characteristics of the light. Walk around a tree and you'll see that one side is brighter (showing the intensity and direction of the light) and that there is a transition from highlight to shadow (showing the quality of the light).

Supplement the Lighting As Needed

Artificial lighting can be used to supplement available light sources on location. However, balancing the light from existing light sources, either natural or electrical, with added strobe or hot lights is a challenge—especially if you are trying to maintain a natural look. Occasionally, you may try a high-fashion look for your seniors, where the artificial light added on location is much stronger than the ambient light. This will result in a scene where the senior is very prominent. For most senior portraits, however, this look is too harsh and not very flattering. As when working with natural light alone, the keys to balancing artificial light with the ambient are intensity, quality, and direction—plus one more: color.

Intensity. A variable strobe and a meter will help you set intensity. Typically, setting the strobe to match the ambient light source, or even half a stop below it, will provide a nice boost to the highlights and the catchlight in the subject's eyes. In tricky situations, where the background is bright or where there is little ambient light available, you may need to match or exceed the ambient light source by a stop or more. As you increase intensity, matching the light quality, direction, and color will become more vital.

Quality. Study and attempt to match the quality of the ambient light source(s). Let shadow edges be your guide. If the main ambient light source is a window with soft light, try a strobe in a large soft box to mimic the window light. If the main ambient light is smaller and more brilliant (*i.e.*, a light fixture like a chandelier), try a direct strobe.

Direction. Establishing direction is easy: place your strobe from the same direction as the main ambient source or slightly more toward the camera position. (*Note:* The more you supplement the ambient main-light source, the more careful you must be to not expand the shadow-to-highlight ratio beyond a natural look [and the recordable range]. You may need to add another fill light, near the camera position or slightly opposite from the main light source. On average, the intensity of the fill light should be ½ to 1½ stops below the main light source.)

Color. Unless you are working indoors in a school gymnasium or pool area, you shouldn't face severe color balancing problems (more than 1000K variances) too often when photographing seniors. Often, in these problematic locations, your strobe lights will become dominant and overpower the color of the ambient light sources. Longer exposure times will make these colors more evi-

dent, though, especially in backgrounds. It is up to you to decide if this is objectionable. For architectural or other commercial interior applications it usually would be—but for senior portraits, it may just add an acceptable warming effect. If it is a problem, then you'll need to work with the color-temperature settings on your digital camera (or your film selection) to match the ambient light source. Then, either avoid using strobes or match their output to the ambient light sources by covering them with color-balancing filters.

The direction of light is important for building dimension and contouring the senior's face and figure.

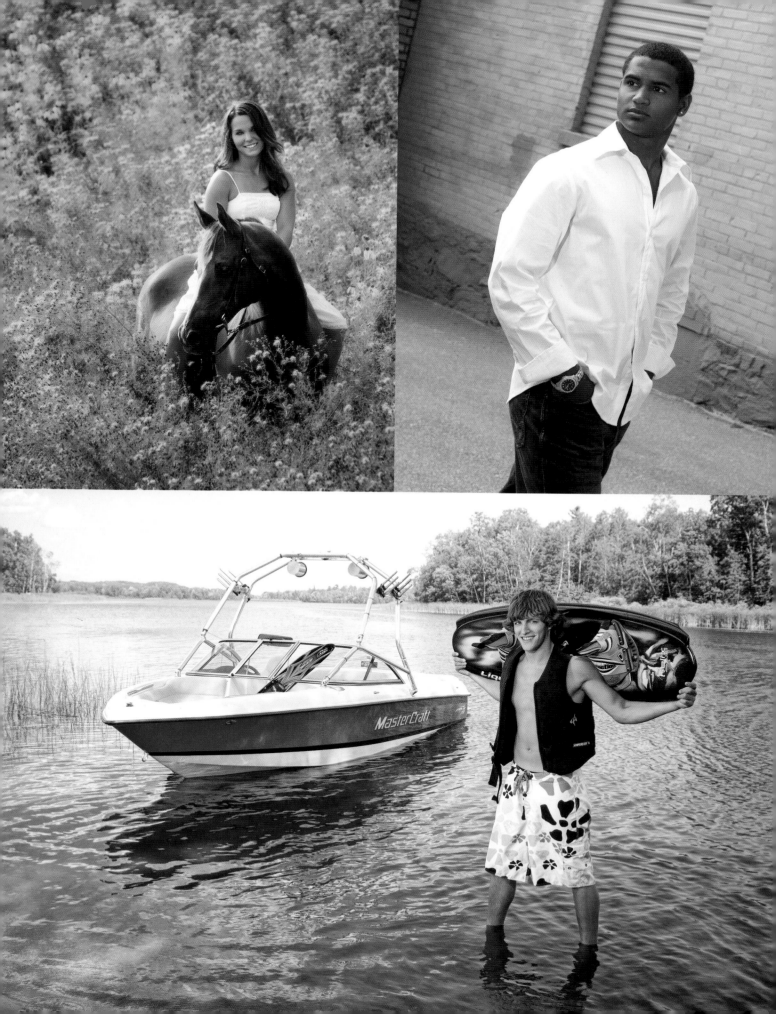

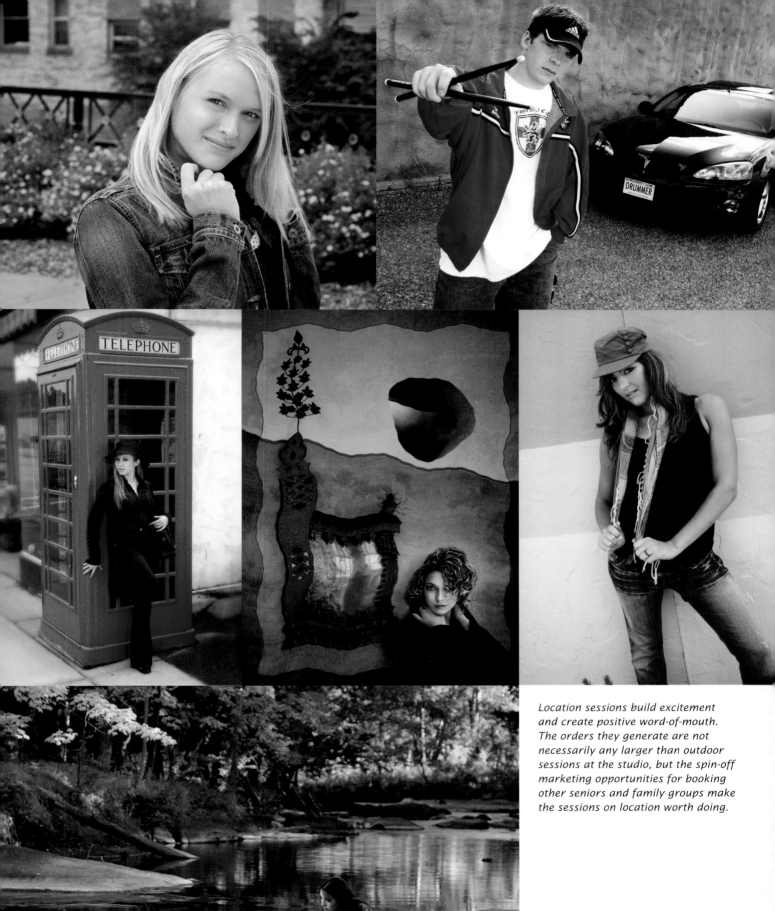

Location sessions build excitement and create positive word-of-mouth. The orders they generate are not necessarily any larger than outdoor sessions at the studio, but the spin-off marketing opportunities for booking other seniors and family groups make the sessions on location worth doing.

8. Image Processing

The freedom of digital to shoot thousands of images does not come without a cost. Every image needs to be processed, which is the "handling fee" of the world of digital. How the images are handled can greatly affect their quality. The complete workflow includes capturing, processing, enhancing, and printing. In this section, we'll focus on the processing stage—but don't be overwhelmed. Find the tools you need and build a workflow that works for you, not against you. Whatever cameras, computers, and software you use, keep these ultimate goals in mind:

1. **Aim for Excellence.** Start right with great posing, lighting, and exposure. Get your images "right" and consistent from the beginning.
2. **Automate.** Hardware and software are tools, so use them to do repetitive work for you (employing customizable defaults, presets, actions, batches, scripts, events, etc.).
3. **Build a System.** Build a system and write it down. Then, be on the lookout for ways to improve image quality and save time.

Optimal Flesh Tones

In senior portraiture, great results mean controlling highlights and shadows, but also getting optimal flesh tones.

Optimal flesh tones have natural-looking color, saturation, and detail. Flesh tones are the most delicate and fragile of all the hues. Any mistakes and their color may shift; they can become dull and lifeless or even oversaturated and unnatural.

True, digital cameras and their firmware have advanced significantly and obtaining great results has become easier. However, there are still many variables that the camera cannot automatically adjust for, and professional portraiture is about producing high-quality images consistently in any conditions.

Exposure. Proper exposure means capturing the maximum recordable range of tones from dark shadows to bright highlights. Digital cameras (and image-processing software) show this range in a histogram, a bar graph that displays the amount of data recorded for each tonal value in the image. Data toward the left is shadow data; data toward the right is highlight data; midtones are in the middle. If data is shown to be outside of the range of the histogram, loss of detail and color control will be the result.

Metering and watching the camera's histogram is the first step toward proper exposure, but alone they are not as precise as necessary. Simply keeping the data within the range is a start, but the image still may be several stops away from the optimal exposure—and optimal flesh tones.

Use of exposure targets can help you get closer to that goal. A gray card is a simple yet effective exposure target. Before capturing images, simply have the senior or your assistant hold a gray card and capture an image where the gray card comprises the majority of the image. Be certain that the gray card is illuminated by the same primary light source that will illuminating the senior subject, otherwise, your target may cause more problems than it solves. Once recorded, study the camera's histogram. There should be at least one peak that represents the gray card data. This peak should be at or near the center of the histogram, because gray is exactly midway between white and black. If it's not centered, adjust your exposure and re-shoot. Con-

Establish Reference Points
On the camera's LCD, histograms can be hard to evaluate for specific exposure readings. Even with careful control, it is easy to vary up to one a full stop from the optimal exposure. Most digital imaging gurus agree that exposure should be within $\frac{1}{3}$ stop from the optimal level—especially when dealing with flesh tones. However, few have identified what "optimal" really means! After years of experimentation, we found another guideline that has worked very well for portraiture, and for output by most professional labs and high-quality, in-studio printers. We have found that if you read the brightness of the diffused flesh-tone highlights, under standard portrait-lighting conditions and working in the Adobe RGB color space, Caucasian skin, the red values should be between 217 and 225, with a median value of 220. Kodak DCS cameras had an eyedropper-type luminometer tool that allowed pinpoint readings at the camera. Unfortunately, most current digital cameras do not. So, this concept will be explored further on page 93, but you should be aware of its potential. Establishing reference points in your workflow will help you work more efficiently and consistently.

Capturing images in the RAW mode gives you the most exposure latitude, even in difficult lighting situations.

sistent use of any exposure target is the key to consistent results. (*Note:* These tools can fade or get dirty and cause deceptive results. So keep them protected and replace them regularly.)

The RAW Mode. Capturing images in the RAW mode is a complex issue that deserves several chapters' worth of explanation. However, using it is not as difficult as some make it seem. Its largest benefit is the great latitude it allows for us to capture great images, even in difficult situations. Of course, full control and accuracy at capture is always our goal and we should never *plan* to fix images later.

If you work in a perfectly controlled world and never make mistakes, you may be able to capture in TIF or JPG mode and get excellent results. For the rest of us—especially in outdoor and on-location senior-portrait sessions—

there are several variables that we may not be able to control entirely (multiple light sources and color temperatures, scene brightness and contrasts, etc.).

The camera doesn't know exactly the look we want. Yet, if you do not choose the RAW mode, the camera is in charge of applying adjustments that change the image data permanently. Any adjustments you make thereafter are "adjustments of adjustments." This jeopardizes image quality, especially if you're working in the compressed and confined world of JPG. Images captured in the JPG mode have less data than a RAW file (and further adjustments and resaving as JPG files causes even more data to be thrown away!).

If you work in sRGB color space, which is the smallest of the color spaces, *and* save in JPG mode, you are *severely* limiting the potential of your images. Even a professional

golfer would prefer putting into a crater as opposed to into a cup the same size as the ball. Using the RAW mode and a medium to large color space (like Adobe RGB) give you crater-sized flexibility and the power to create perfect and near-perfect images. (*Note:* Although some image-processing applications now allow for "RAW-style" image processing of TIF and JPG files, you will quickly find that they are limited to minor adjustments. Sometimes even slight adjustments to contrast, for example, can cause severe changes and shifts to color.)

Five Keys to an Efficient Workflow

An efficient workflow has five specific characteristics: high quality, consistency, organization, speed, and a plan for archival longevity. Within the optimal workflow, these five components are all interrelated and interdependent. The following are the elements of each that are common among all of the major image-processing software applications (Adobe Camera Raw/Bridge, Adobe Lightroom, Apple Aperture, Bibble Pro, BreezeBrowser, Capture One, etc.):

High Quality. Maximum quality should be the goal of every professional photographer.

1. *Capture and process in the RAW mode.* This creates the greatest amount of data and allows for nondestructive editing.
2. *Manage white balance and exposure.* These are the most vital of the image-processing adjustments. They are the basis of every image and their settings will affect several other adjustments. So, set them first.

 In your software, look for an eyedropper-type tool and click on a neutral area (like a gray card) to automatically set the white balance, or set it manually using a slider. If a neutral area that was illuminated with the same light as the subject is set to neutral, the subject's color will be more accurate.

 Exposure is usually read with an eyedropper and info palette, then set with a slider. If there is a gray card, read the gray card. When gray card is perfectly exposed, the red, green, and blue channels should all read about 127. Again, we have found that (working in Adobe RGB) once you have set your white balance, adjusting the exposure so that

the diffused highlights on a Caucasian skin tone are at 217–225 in the red channel will yield very good results. (*Note:* Of course, this depends on the individual's skin tone. Also, be sure to read from a cheek, chin, or forehead [not a sweaty, shiny specular highlight].)

3. *Control the shadows and highlights.* Like camera firmware, the image processing software should have a histogram—and possibly shadow and highlight alerts. These will tell you if any data is in jeopardy of being clipped and lost (blacks that are jet black and/or whites that are pure white and lacking in detail and color accuracy). Usually, there are sliders for controlling each, but their names vary between software applications. Adjust them if necessary but only in small amounts. Try to keep all relevant image data greater than 10 and less than 245 to maximize detail when printing.
4. *Watch the contrast.* At this point, adjusting contrast should only be a tweak. Scene brightness, lighting, and prior processing settings should already have established good contrast. Adjusting contrast should be done carefully to enhance the image and not overly darken shadows or brighten highlights.
5. *Check the saturation.* The level of saturation is critical in portraiture. With too little saturation, your subjects will look pale and lifeless. With too much, they may look like lobsters. Establishing the right level is somewhat subjective, depending upon personal tastes. Small adjustments can make a big difference.
6. *Adjust the noise and sharpness levels.* Noise and sharpness adjustments are somewhat controversial and variable among cameras of different resolutions. Also, they are functions of exposure and contrast. Newer professional, high-resolution cameras produce sharper images with less noise. Some image-processing software also includes special sharpening and/or noise-reducing algorithms. Some professionals choose to sharpen and/or reduce noise later in Photoshop, or sometimes with third-party plug-ins.

Consistency. Consistency is based mostly upon establishing a common-sense, systematic approach to the entire

Establishing a solid file-organization system, applied to the images from each and every shoot, is critical to workflow, sales-session, and image-processing efficiency.

photographic process. The more careful you are to capture images that are similar, the less time you will need to process, retouch, enhance, and prepare them. If possible, work on several images simultaneously or adjust one and then apply the same adjustments to others. Avoid adjusting images individually and needing to constantly compare and readjust. Using guide tools such as a gray card or a Macbeth Color Checker as reference points while setting color will save a great deal of time.

Organization. Establish a meaningful file naming, numbering, and folder system that will be easy to use and remember. Each of our senior clients has at least five folders when their order is complete:

1. *An Original Set (labeled "org").* This set is built when the images are imported from the camera or card.

2. *An Adjusted Set (labeled "adj").* This is a copy of the original set made after making the RAW image-processing adjustments.

3. *A JPG Set (labeled "jpg").* This is a copy of the adjusted set, but saved as JPG files. These files are used for projecting for sales, making proofs, etc.

4. *A Retouched Set (labeled "ret").* These are copies of the images (saved as TIF files) from the adjusted ("adj") set ordered by the customer after retouching, enhancements, and cropping.

5. *An Order Set (labeled "ord").* This is copy of the retouched set saved as JPG files to be sent online to the lab for printing.

Speed. Automation is the key to a speedy workflow and to "getting your life back." There are several power tools available to help make the software do work for you.

1. *Arrange and save your workspace.* Arrange your most-used windows, menus, etc. in a manner that is easy for you to use and conserves display space. Then, save the workspace.

2. *Let the software do its job.* At certain points, especially when images are being cached and converted to thumbnails for viewing, it is best to let the software to finish its processing before proceeding. If you don't, it may overload your computer's processor(s) and slow down all the processes. So, just be patient.

3. *Make quick and easy edits.* Don't waste time adjusting images you don't need. Find functions such as slide shows, rating systems, and filters to speed the selection process. Light table views of thumbnail images typically do not show the images large enough or clear enough to be useful for making final selections; a slide-show viewer will. Advance

Actions, custom defaults, and other automated processes can help you refine your images to perfectction—without spending hours at your computer.

through a slide show manually and use keystrokes to rate the images. A star or similar system works well (0 stars = out, 5 stars = in, etc.). After rating, use filters to separate the images into groups (in and out).

4. *Create custom defaults.* Most professional image-processing applications have very good custom default settings for each of the specific professional camera models. However, you may have special preferences or you may wish make your different cameras produce consistent images. If available, creating custom defaults will automate your workflow, because the software will automatically convert the images as they are imported. Be aware, however, that the default settings will be applied to *all* images from a camera model, *every* time.

5. *Create custom presets.* Presets are similar to defaults, but they need to be applied manually. You can create a preset to adjust a collection of adjustments, or just one specific one, and then access the presets from a menu or even a keystroke. The presets can then be applied individually or to a group of selected files. If you find you're making the same adjustments repeatedly, but not quite *every* time, presets are very efficient workflow tools.

6. *Adjust multiple images simultaneously.* If several images were photographed under the same conditions, you may be able to adjust them simultaneously. Alternately, you may be able to adjust one, select the others, and apply the identical adjustments to them.

7. *Crop and dust spot.* If necessary, cropping and dust spotting during image processing can save time. Some types of sessions require the images to be cropped consistently (all 4x5s, 5x5s, etc.). Applying a crop tool to a group of selected images is much faster than them cropping individually. Although in-camera dust removal systems are popular and dust spots on sensors are becoming less common, they still exist. Because they are in the same location from image to image until the sensor is cleaned, you can remove them on one image and then let the software remove the rest (*Note:* There is some potential for causing new problems

when doing this, so be careful.) Cropping and dust spotting a RAW file during image processing has the additional benefit of being nondestructive; these files can be changed repeatedly without harming the image.

8. *Make enhancements.* If desired, you can apply enhancements to a set of images during processing. You can convert images to black & white, add vignettes, create high-contrast looks, etc. Custom presets are very effective for saving and reapplying these enhancements.

Archival Longevity. Backing up and properly saving your images is vital in every workflow.

1. *Save-Save-Save, Copy-Copy-Copy.* Fortunately, most processing software automatically saves adjustments as you make them. Anything can and will happen, so save your progress often. Make copies of your image files. Keeping at least two copies of each image is good insurance.

2. *Use high-quality media and storage devices.* There are several storage options available. Some are good, some aren't. Some CDs and DVDs can actually start losing data in two years or less. Some low-cost hard drives crash often. Use silver or gold CD/DVDs that are rated archival for 100 years or more. Also, use archival cases and sleeves to store the discs—and alcohol-free markers to label them and ensure their long life. External hard drives such as LaCie USB or Firewire hard drives are excellent tools for use in your work and are very reliable. However, future compatibility issues put their archival value into question.

3. *Use standard file types.* TIF and JPG are the most popular image file types and are supported by most all types of software. If you are capturing images in the RAW mode using the camera's proprietary image format (Canon's CR2, Nikon's NEF, etc.), you need specific image-processing software designed to read them. Most of *today's* popular processing applications do read the major raw file types, but what happens as they change or are possibly even discontinued in the future? They may not be supported forever, and you'll be stuck with years of files that can't be opened.

Adobe DNG

Adobe introduced the DNG (digital negative) file format in order to make RAW files more universally compatible—and it *is* more archival, because it is publicly documented. To use DNG, you must convert your camera's RAW files to DNG files using a conversion utility. This can easily be done as you import your images from the camera or card to your computer via a DNG converter, an autoplay Photo Downloader, the "Get Photos from Camera" function in Adobe Bridge, by saving in Adobe Camera Raw, or with Adobe Lightroom. If you use multiple brands of cameras, converting them all to the DNG format also makes them easier to handle as a group.

J.D.'s Everyday, Easy-Bake, Image-Processing Workflow Recipe

The following is a brief summary of our everyday workflow for processing senior-portrait image files. We have developed various specific workflows, depending upon the type of job (seniors, children, families, memory mates, candids, sports, etc.), but this is a good representation of the majority of steps involved.

1. *Download and convert the images.* Insert the memory card into the card reader. Go to Adobe Bridge and go to File>Get Photos from Camera. Save the image files to a hard drive in a folder labeled "org" (see page 93) and named with their work-order number and first letter of their first name (for example, "12345s"). Convert the files to DNG and open them in Adobe Bridge. Since we use custom Adobe Camera Raw defaults, the files are automatically adjusted to our base preferences as they are copied.

2. *Select the images.* In Bridge, view all the images in a slideshow, advancing through the images and rating the images with stars (0 = Out; 1 = Gray Card; 3 = Maybe; 5 = In). If necessary, re-review the three-star images, decide whether they're in or out, and change their rating.

3. *Filter and white balance the needed images.* In the Bridge Filter window, select the one- and five-star images and open the files in Camera Raw. In Camera Raw, group the selected images and their gray card image, then click on the gray card with the White Balance tool to set the white balance.

4. *Filter, copy, and rename the images.* In Bridge, filter to select the five-star images, go to Tools>Batch Rename to rename and copy these files to a new folder named "adj" (see page 93).

5. *Adjust the exposure settings.* Select all images in the "adj" folder and open them in Camera Raw. Adjust the exposure of each image by placing the cursor on an area of the senior's face with a diffused, flesh-tone highlight (usually the cheek or forehead) and using the Exposure slider. For Caucasian skin, adjust the slider until the red value reaches about 217–225 (220 is about the average in the Adobe RGB color space). Other skin tones may vary between 185 and 230.

6. *Crop, straighten, dust spot, and make other adjustments (optional).* If necessary, crop the images to remove unneeded image area, straighten, and dust spot. Make other adjustments if needed (possibly to contrast or saturation).

7. *Create a set of JPG image files for sales (optional).* In Bridge, go to Tools>Photoshop>Image Processor to create a new folder of JPG image files. Image Processor converts the files to JPG, enhances them with an action, adds our copyright data, and copies the images to a new "jpg" folder (see page 93). We use these JPG files to project to the customer during their sales appointment and to create proof prints.

8. *Burn the customer CD.* Write the "adj" and "jpg" folders to a CD, write the senior's name, school, work-order number, date, and "adj" and "jpg" on the disc. We use silver Mitsui Advanced Media; Mitsui designed the process for coating discs and making them archival.

From Image Files to the Final Output

Now you've got the images on permanent files, what's the next step? You could go to Sam's Club and have them printed, but if you want to be a true professional you don't take shortcuts or settle for anything less than the best you can give your clients. It's time for you to add the frosting to your presentations. The following sections will show you how to use Photoshop to create a professional finished image. Retouching corrects problems. Enhancement helps to make our senior subjects look their best without making them look like someone else. Art effects are excellent tools for add-on sales.

Basic skin retouching is explained using the Clone Stamp and Patch tools. Study how to use the History Brush to enhance highlights and shadows on the face and eyes. Other quick improvements to the eyes and teeth will make your work stand out from your competitors. Learning these skills will enable you to take your portraits from average to exquisite likenesses of your subjects. Also included are a few retouching, enhancement, and artistic effects based on recipes from our *Wackers' Digital Cookbook and CD* (available on our web site).

Basic Skin Retouching

We use two main tools for retouching: the Clone Stamp tool and the Patch tool. They are effective mechanisms for correcting blemishes, scars, rashes, wrinkles, eyebags, stray hairs, clothing problems, etc.

The Clone Stamp Tool. The Clone Stamp tool is used to replace one area (a problem area) with a selected area (one that's better). To use it, select the Clone Stamp tool and set the options in the options bar. For dark blemishes, set the blend mode to lighten. For light blemishes/scars, set the blend mode to darken. Set the opacity between 20 and 30 percent for both darken and lighten modes. Set the flow to 100 percent, disable the airbrush setting, and check the Aligned box. Then, choose a soft-edged brush that is similar in size to the blemishes you will be concealing. For a dark blemish, press Alt/Opt and click on a nearby area of skin containing no problems. This is your source area. For a light blemish or scar, press Alt/Opt and click on a darker area of skin. Then, just move your cursor to the blemish and click until it is lightened or darkened to blend. (*Note:* Using a sliding stroke with this tool may give you a smeared/plastic look to the skin.) Keep changing sampling points as needed until you have eliminated the blemishes.

The Clone Stamp tool also works well for softening lines and wrinkles. To keep the character of the person's face, just lighten the lines a little with the Clone Stamp

Before and after retouching with the Clone Stamp tool.

tool adjusted to the lighten blend mode. Do not remove the lines completely.

The Clone Stamp tool can also be used effectively to eliminate eye bags. Simply sample a lighter skin area from just below the eyebag and tap the dark areas away (using the lighten blend mode).

The Patch Tool. The Patch tool can be used to repair many problems. After selecting the Patch tool, go to the options bar and click on the Source button. This allows you to loosely circle the problem area, then drag to a nearby area that will replace and automatically blend over the blemish, matching the texture and shading of your source area. The Patch tool works especially well for scars.

The Patch Tool works well for the eyebags that are quite dark. First, make a background copy in your layers palette. With the Patch tool set to Source, loosely circle the dark eyebag and drag the selected area to a lighter area of the face. If this results in an undereye area that is totally lacking in any dimension, adjust the opacity of the over-laying layer (in the layers palette) until the proper amount of dimension is brought back to that area—it's important to keep the realism and character of the face. This method

works well anytime an area is too dark but you do not want to take all the detail away.

Highlight and Shadow Enhancements

To brighten highlight areas or deepen shadow areas use the History Brush.

The History Brush. The History Brush is one of the most powerful, yet underappreciated portrait enhancement tools available in Photoshop. Besides its use in a multitude of other photographic applications, it excels at enhancing highlights and shadow areas. It is far superior to using the Burn and Dodge tools, as it applies its effects while using color from the image itself rather than changing the hues toward muddy neutrals. Once it is set properly, using it is as easy as painting by numbers. You do not need to make selections or choose colors to work with the History Brush.

Stray Hair and Dust
The Patch tool is almost always faster than the Clone Stamp tool at removing dust. While the Patch tool and the Clone Stamp tools both work well on stray hairs, using the Patch tool can result in edge color changes when blending into hair edges. This can be fixed by following up with the Clone Stamp tool. In this case, you would set it to 100-percent opacity, being careful to sample from identical colors and tones in the background area.

With simple retouching, every subject can have flawless skin.

The History Brush allows you to paint from a recorded point in time (in Photoshop-talk, "a history state"). As you retouch and enhance an image, you can capture points in your progress by taking snapshots—just click on the camera icon at the bottom of the history palette. The recorded history states will appear at the top of the history palette and remain there throughout the editing process. Although you may create and use several, we typically do not need more than two recorded states: the original state (which is automatically recorded when the file is opened) and a second state (which records the point following any color adjustment and basic skin retouching). Failure to capture a snapshot *following retouching* will risk the reapplication of problems previously removed (painting blemishes, scars, unadjusted skin tones back onto the image). To keep organized, you may double click on the name of the history state in the history palette and rename it with the more meaningful name or reference.

In the process below, the source and the destination will actually be the *same* history state—a snapshot of the retouched image. To add highlights and shadows, however, we'll set the blend mode so that the source data painted onto the destination is lightened or darkened. This is how the full potential of the History Brush as a portrait-enhancement tool is reached. As noted on page 96, the blend modes allow you to choose exactly how an effect is applied. For example, you can change only the lightness or darkness of an area without disturbing its color, contrast, saturation, etc. This makes it possible to work more efficiently—and you will obtain superior results as your enhancement will be automatically blended.

Highlights and Shadows, Step by Step. Here's how to do it, step by step:

1. After you have completed retouching, take a snapshot of what has been done up to this point. You

don't want to bring back any problems from a past history state. To do this, click on the camera icon at the bottom of the history palette. Once a snapshot is taken, you will be working from this current point of time.

2. Click on the History Brush icon to left of the new snapshot.

3. Select the History Brush tool and choose a soft-edged brush (the size will vary depending on the area you're working on). Then, set the desired blend mode. The most effective ones for highlights and shadows are the screen mode (makes highlights brighter) and the multiply mode (makes shadows deeper). Start with a low opacity—in the neighborhood of 10 to 20 percent.

4. Brush on the desired highlights and/or shadows. Working at low opacities will create soft effects. If more is needed, apply multiple strokes until you get the effect you are looking for. When making facial highlights, be careful to keep your values

within the "printable range." Do not go much beyond a red value of 220 (watch the RGB numbers in the Info palette).

Where to Place the Highlights and Shadows. How do you know where to put the highlights? How do you know where to put the shadows? Let the lighting style of the portrait help you. Look for the catchlights in the eyes and look for any shadow next to the nose. If the portrait's main light is coming from the left, the highlights will be stronger on the left and the shadows will be stronger on the right side of the face. Now you know where to begin enhancing the highlights and deepening the shadows.

Seven Facial Highlights. There are seven areas of where you can consider adding highlights on the face using the History Brush in the screen mode. These are:

1. Above the left eyebrow tip
2. Above the right eyebrow tip
3. Down the nose

Enhancing the shadows with the History Brush.

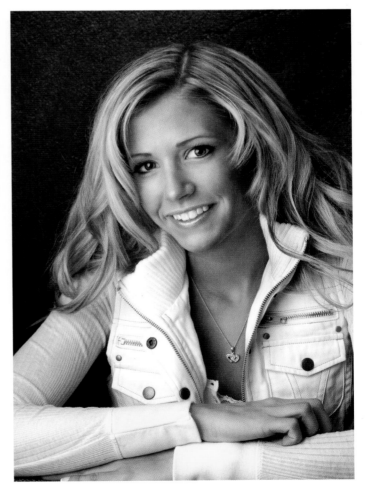

4. Tip of the nose
5. Make the cheek area under the eye closest to the main light lightest
6. Make the cheek area under the eye farthest from the main light less light
7. Chin area under the lip area

Additional areas that can be highlighted are under the nose to the tips of the lips; above eye under the brow; and any additional pleasing accent lighting you may want to place along the edges of the jaw.

Four Eye Highlights. There are four areas of where you can consider adding highlights in the eyes using the History Brush in the screen mode. These are:

1. Main catchlight
2. Crescent glow (create or enhance) on the opposite side of the main catchlight
3. Along the edge of the iris in the whites of the eye closest to main light
4. Along the edge of the iris in the whites of the eye farther from the main light (highlight to a lesser degree)

Do not lighten the whites of the eyes all the way up to the eyelids. Leaving the area under the lid in shadow creates roundness and believability. Lightening the entire whites of the eyes gives a cut-and-paste look.

Three Facial Shadows. There are three areas of where you can consider darkening shadows on the face using the History Brush in the multiply mode. These are:

1. Next to the nose on the opposite side from the main light
2. Along the edge of the jaw line, from under the edge of the eye to the chin
3. Along the forehead next to the hair line

Additional areas that can be put into shadow are the hands, if close to the face, and the neckline.

The History Brush Throughout the Frame. The power of the History Brush is that it turns a flatly lit image into an image with shape and form, an image that shows more "punch" through its highlights and shadows. The History Brush can, of course, also be applied to any part of the image—hands and feet, clothing, props, and background—using these same methods.

Vignetting with the History Brush. A final touch that will give your image a professional look and sets your senior apart from the background is a slight vignette with the History Brush. A vignette is the lightening of the edges of your image in a light (high-key) image or darkening the edges of your image in a dark (low-key) image. This should be done using a large, soft-edged brush.

Correcting and Enhancing Teeth

Sometimes, teeth are not as white as they could be. Sometimes, teeth that are slightly out of line shadow other teeth. Sometimes, there is a slight crack or chip that can be fixed.

ImageTrends PearlyWhites. We feel that the best way to whiten and brighten teeth is using ImageTrends Inc. PearlyWhites, a Photoshop plug-in (available for trial download at www.imagetrendsinc.com, or use the coupon

Adding highlights in the eyes with the History Brush.

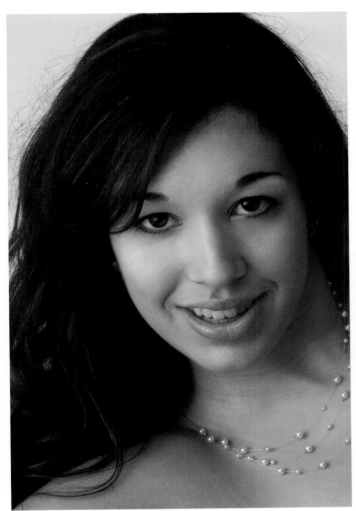

This example has a slight chip in one of the front teeth. This was repaired by using the Clone Stamp tool in the lighten mode, sampling from the corner of the other front tooth. ImageTrends PearlyWhites was also used to brighten and whiten the teeth.

Removing braces is less complicated than it might seem.

About Layer Masks

Layer masks allow you to selectively bring parts of the background image through an overlying layer. Sound confusing? It really isn't once you realize its power. The following exercise shows your how to use layer masks to darken the background of an image, bringing the subject through unchanged to make the subject stand out. The same principles can be applied to a number of imaging situations (*i.e.*, composites, head swaps, artistic edges, etc.).

1. Make a background copy layer. Go to Image>Adjustments>Curves. Click and drag the center of the diagonal line downward to darken the overall image. When the darkening on the background is what you want, click OK. Now your background copy layer looks darker than the bottom background layer (clicking the layer visibility (eyeball) icon on and off will show you the difference).

2. With the background copy active in the layers palette, go to the bottom of the layers palette and click the Add Layer Mask icon. A white box icon will appear in that layer. Next, make sure your foreground color is set to black.

3. Select the Brush tool and choose a soft brush in the normal mode. The size of the brush and the opacity will depend on the amount of the original image you wish to bring through the mask. As you begin painting with this brush, you will notice areas on your mask that are letting the bottom layer show through. (If you make a mistake, you can switch your foreground color to white; painting white onto the mask will make the underlying layer invisible again.) This simple method can make your image look more professional.

The edges of this image (left) were edited with a spatter brush on a layer mask to blend it into the senior's composite (right).

code PHOTOBYJD for discounted pricing). It also whitens the whites of the eyes and slightly enhances the highlights on the face.

Lightening and Whitening. Working with your image in Photoshop, make a background copy layer. Choose the Lasso tool and loosely circle the teeth. While the teeth are selected, go to Curves (Image Adjustments>Curves) or click the New Adjustment Layer button at the bottom of the layers palette and choose Curves in the drop-down menu.

In the Curves dialog box, choose a channel. If the teeth look yellow, choose the blue channel (the opposite of yellow). Click the center of the line and drag it up slightly until the yellow is reduced. You can check and uncheck the preview box in order to see what they look like. If teeth seem to be a bit too dark, choose the RGB composite channel and click on the center of the line. Drag this up

slightly to increase the brightness. When you have the desired results, click OK.

If the edges of the Lasso selection are visible, use a layer mask. This will allow you to selectively reveal the layers beneath the corrected layer (see the sidebar above).

Removing Shadows. When crooked teeth cast shadows on other teeth, you can remove the shadows using the History Brush tool (refer to pages 97–98). Setting the History Brush to the screen mode will brighten the darker teeth. You can also use the History Brush in the screen mode to quickly whiten all the teeth.

Removing Braces. To remove braces, select the Patch tool and click on the source button. Select the braces on one front tooth. Click and drag the selection to a clear skin area on the subject's cheek or forehead. The Patch tool will automatically remove the braces portion and put some texture from the skin into the tooth (don't ask why it

works—it just works!). Move on to the next tooth until you have all the braces circled and replaced with braceless teeth.

Then, apply the ImageTrends PearlyWhites plug-in (or use one of the other methods described for whitening teeth). The teeth should now have a really nice white color. Use the History Brush in the screen mode to apply and extend existing tooth highlights. Finally, apply a little noise to the overall image to blend any noticeable work.

Removing Glass Glare
(and Other Glasses-Related Problems)
Removing Unwanted Glare. If the glare from the glasses is over the eyeball, select the Clone Stamp tool. Set the blend mode to normal, set the opacity to 100 percent, and choose a soft-edged brush. Then, clone over the glare using data from the unaffected eye. If both eyes have glare, then clone from the remaining good parts of either eye. This will take time.

If the glare is on the eyelids and/or lashes, select the Brush tool. Set the blend mode to darken, set the opacity at 20–30 percent, and use a soft-edged brush. Use a small brush for the lashes and a more broad brush for the lid. Make sure to carefully match the skin tones that surround the glare area.

Removing Refraction. Select the Clone Stamp tool. Set the mode to normal, set the opacity at 100 percent, and choose a soft-edged brush. Sample the edge you want to clone, then move the brush to where you want the new edge. Clone that edge and the rest of the skin tone. Next, blend the new section with the rest of the skin by changing the Clone Stamp tool's blend mode to lighten or darken, depending on the tone you wish to change. Set the opacity from 20–30 percent and use a soft-edged brush. Then blend the tones.

You can also remove refraction using the Liquify tool. Go to Filter>Liquify, then select the Push Left tool (formerly the Shift Pixels tool). The larger the brush for this

Retouching glare and other problems creates a more flattering look for those who wear glasses.

tool, the more information is shifted; the smaller the brush, the less information is shifted. To shift pixels to the right, brush along the edge to be moved, moving the brush downward. To shift to the right, move the brush upward. To shift up, move the brush right and to shift down, move the brush left.

Removing or Lightening Unwanted Bow Shadows. Select the Clone Stamp tool and set the mode to lighten. Adjust the opacity to 20–30 percent and use an appropriately sized, soft-edged brush. Sample a nearby area that is unshadowed by pressing Opt/Alt and clicking, then click over the shadow area to lighten it.

Artistic Enhancements

Being able to do your own retouching and enhancement will enable you to be more in control of your workflow. It

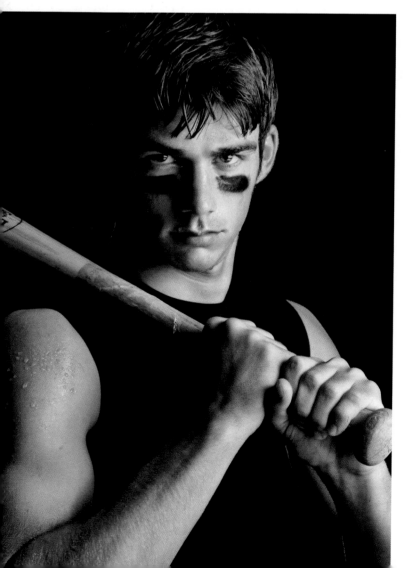

will also save you money in lab bills. But using your artistic talents to create new product lines is what will really increase the bottom line. In the following section are several techniques that have led to new product lines and new profits for us.

Converting to Black & White. Black & white portraits are a popular choice among seniors—and there are about 101 ways to convert color digital image files to black & white. Once again, it's time to think as a professional. What method will produce top-quality results and be most efficient? For years, we used the Lab conversion method, adding layers in various blend modes to further enhance the images via an action. Currently, we working with Photoshop's Black & White adjustment layer, because it produces comparable quality in slightly less time and is more flexible.

To use the Black & White adjustment layer, click the Create New Fill or Adjustment Layer icon at the bottom of the layers palette and select Black & White. In the Black & White dialog box, adjust the color sliders to change how each color is converted to neutrals. Our favorite settings for everyday black & whites are: Red=65, Yellow=90, Green=35, Cyan=60, Blue=50, Magenta=40. Red and yellow are the most important as they control how skin and hair are converted. Green affects grass and foliage. Cyan and blue control the skies and blue jeans. Magenta affects lipstick. Of course, certain outfits (or paint) can also be affected by certain color adjustments. Once you have settings that work well for you, click on the Preset options menu in the Black & White dialog box. Select Save Preset and name your settings. When you need to apply the same settings again, your custom preset will appear in the Preset menu of the Black & White dialog box.

Tinting or Toning. Tinted (or toned) monochrome images are still popular with seniors, especially—and interestingly—sepia-toned images. In Photoshop, tinting is easy. After setting the color sliders to convert a color image to black & white with the Black & White adjustment layer (as described above), check the Tint box and set the Hue and Saturation sliders to achieve the desired effect. To create a sepia look, try: Hue=27, Saturation=10. For a cool blue tone, try Hue=220, Saturation=10.

LEFT—*An image converted to black & white using Photoshop's Black & White adjustment layer.* FACING PAGE—*Image toned using Photoshop's Black & White adjustment layer.*

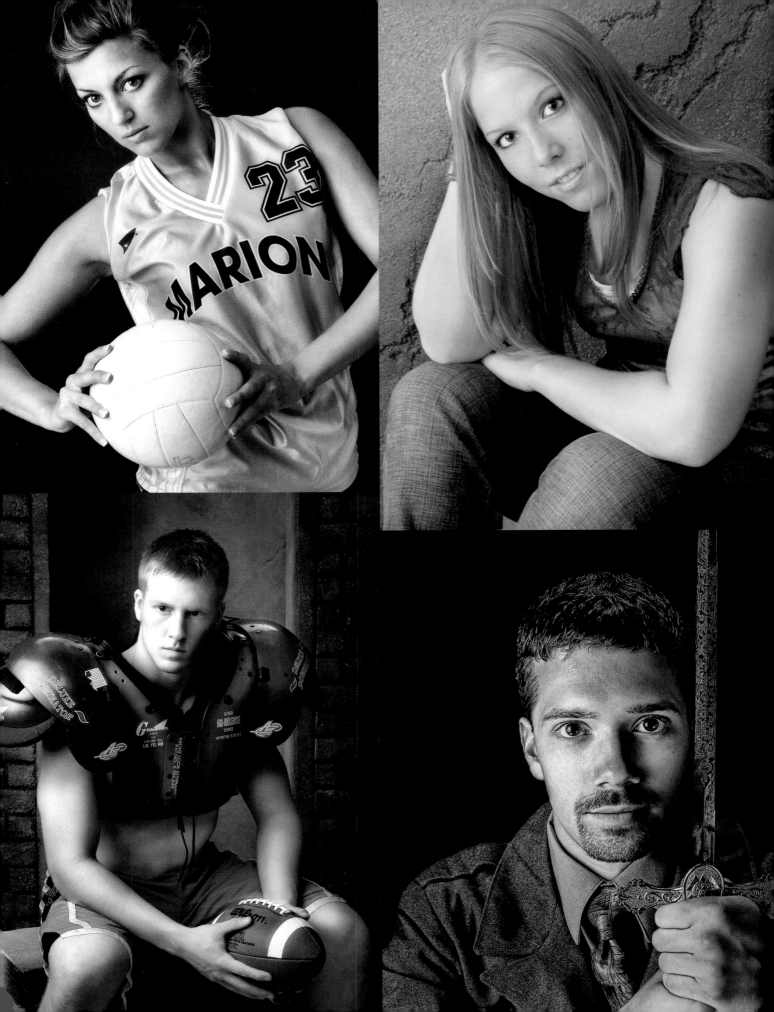

Hand coloring using the Black & White adjustment layer and layer mask.

Hand Coloring. Not all senior images will look good as hand-colored image, as they are typically flatter in appearance and less dynamic. Look for simplicity—plain backgrounds and plain clothing. Indoor shots also look better hand-colored than outdoor shots. When you've selected your image, apply the conversion to black & white described on page 104. In the Black & White dialog box, check the Tint box and set the Hue slider to 24 and Saturation to 4 percent. Click OK. This gives the image a Daguerreotype-Sepia look. In the layer that is now called

Black & White, click in the layer mask thumbnail. Choose the Brush tool, then select a large, soft brush set at 30 percent opacity to paint back some of the original color from the underlying layer. Work across the face, neck, hair, clothing, and anything else that needs to have some color. If the lips and eyes need more color, just keep painting on that layer mask. Use a smaller brush for the more detailed areas.

Spot Color. Spot color is a more pronounced effect that is useful for highlighting certain elements in a black & white image (school colors in uniforms, flower petals, specific pieces of clothing, etc.). The technique for creating this look is basically the same as the one used for hand coloring—just skip the tinting. Additionally, the colors are brought back more significantly. Simply use harder edged brushes with higher opacity settings to restore more intense color.

Add Some Texture

To finish the hand-tinted look, add some texture. This makes it look like the image was printed on old fiber-based paper. To do this, first make a background copy. Go to Filter>Texture>Texturizer. Select sandstone in the texture choices. Set the Scaling to approximately 60 percent and the Relief to 5. If the texture seems too heavy, reduce the opacity of the layer in the layers palette. (*Note:* The settings for this filter are resolution-dependent. These settings are for an 8x10-inch image at 250ppi. If your image is larger or smaller, you may need to adjust the settings.)

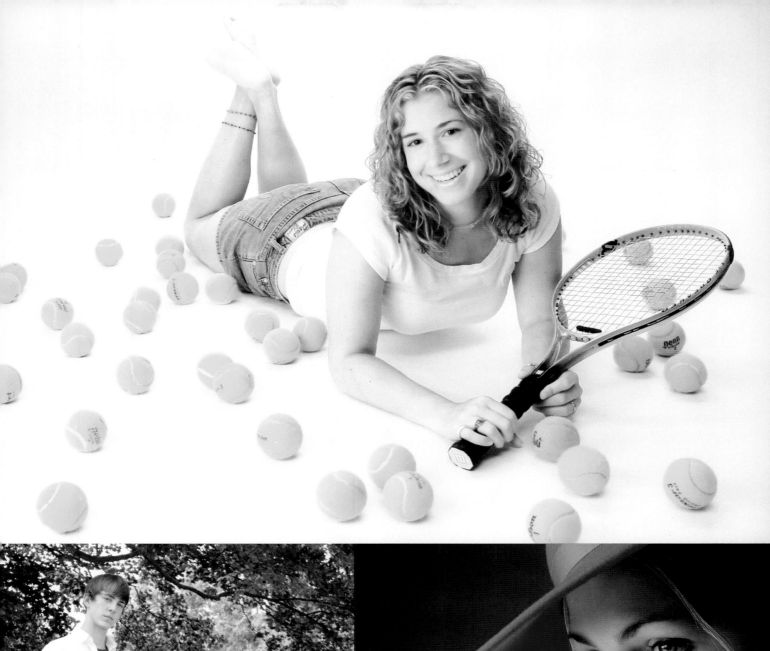

Spot color was added using the Black & White adjustment layer and layer mask.

An image enhanced with the Diffuse Glow filter.

Diffuse Glow. This is a filter with some high-key applications. It adds a glow and grain that creates a high fashion look and it's easy to use.

1. Set your background color to white. This will be the glow color. (*Note:* You can use other colors, but your subject may look like an alien.)
2. Go to Filter>Distort>Diffuse Glow and set the graininess to about 6–7, the glow amount to about 4–6, and the clear amount to about 7–10, depending upon the image size and your preference. Click OK.

The High-Contrast (Illustrative) Look. This illustrative effect, which is popular in advertising photography, gives your image a look that is more saturated and has higher contrast overall.

1. In your Layers palette, create a Brightness/Contrast adjustment layer. Set the Brightness to 5 and the Contrast to 25 (making sure the Use Legacy box is not checked). Click OK.

2. Set the blend mode of the adjustment layer (created in step 1) to Luminosity.
3. Make another adjustment layer, this one set to Hue/Saturation. Do not check the Colorize box. Set the Hue to 0, Saturation to 15, and Lightness to 0. Click OK.

Painted Portraits in a Snap!

If you like the painted look but prefer to have a finished image in a few minutes rather than a few days, this method is for you. Download and install Alien Skin's Snap Art Photoshop plug-in at www.alienskin.com.

1. Prepare the image normally (color correcting, retouching, enhancing, etc.).
2. In the history palette, click on the camera icon to create a new history snapshot (to record the enhancements/changes made in step 1).
3. Go to Filters>Alien Skin Snap Art and select a filter. Oil Paint is our absolute favorite, but all the filters are great. We often use Pencil Sketch, Pointillism (for a George Seurat style), Stylize

(Neon Outlines), and Comics (for a Marvel comics style), too. Under the Settings tab in the Snap Art dialog box, the Portrait presets (when available) are usually our favorites. The settings are ultimately adjustable, but often a preset will give you the effect you need with, at the most, only minimal tweaking of a few sliders. Small brush sizes, high edge preservation, low color variation, slight saturation boosts, and low canvas textures seem to work particularly well for painting portraits. Preview Split is a handy option for viewing the image with and without the effect. Check the Create Output in New Layer Above Current box under the Basic tab. Then, click OK to run Snap Art and apply your chosen effect on a new layer in Photoshop.

4. In the history palette, click on the camera icon to create a new history snapshot (to record the effect

applied in step 3.) This is a safety precaution only. If you make a mistake in step 5, it allows you to revert to this snapshot and paint away your mistake.

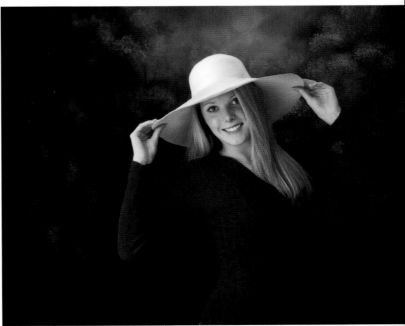

RIGHT—*Image without Alien Skin.* BELOW—*Image showing Alien Skin*

5. Set the History Brush icon, on the history palette, to the snapshot created in step 2—just before applying the Snap Art filter. Then, use the History Brush to reduce the intensity of the painted effect where it may be too strong in critical areas (subject detail and some scenic detail, especially in the same depth plane as the subject). This is a critical step that can make the difference between a saleable portrait and just an addition to your portfolio. The blend modes available for the History Brush are the key. With the blend mode set to Normal, the opacity at 30 percent, and the Airbrush setting off, lightly paint over detail areas (eyes, nose, mouth, clothing edges, etc.) to gradually restore original detail. Don't go too far, though, or the subject will look cut-out. The restored detail will probably appear flat in comparison to the art effect. To remedy this, change the blend mode of the History Brush to Soft Light and paint to restore more original detail, but with a color and contrast boost that will help blend the subject into the overall painting. If necessary, use the Multiply and Screen modes to boost the shadows and highlights. Finish by using the Normal mode to eliminate any objectionable paint strokes on the skin or elsewhere.

Adding Text

Adding text to images is a quick and easy enhancement that is particularly well-liked in senior portraiture. The most difficult steps are deciding what font and effects to use. A few tricks can make the process of adding text more efficient and help create more dynamic looks.

To add text, select the Type tool from the tool bar. You can set the options before or after typing, but you may want to set at least some of them before you start—just for visual sake. Choose the type orientation, font family, font style, font size, the anti-aliasing method, the alignment of the text, text color—and if you would like to create warped text.

FACING PAGE—*Images enhanced with the Snap Art Oil Paint filter.* **BELOW**—*Text additions are very popular in senior portraits.*

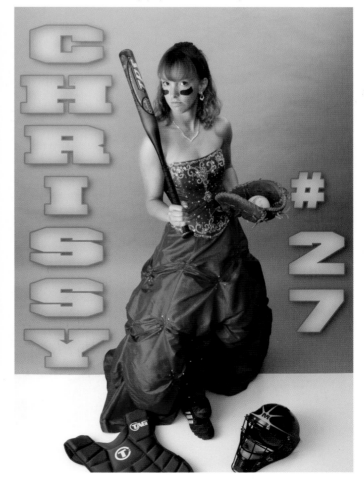

Here, the image has been converted from color to black & white so you can see the simplicity and beauty of adding text.

Once text is added, you can edit it by clicking and dragging over it to highlight it. Type Ctrl/Cmd+H to hide the "negative" selected look. Once the text is highlighted, you can click on the font name in the font family menu (in the toolbar) and use the up and down arrow keys to scroll through your various fonts. You can also highlight the controls for other attributes (font size, etc.) and adjust them as needed. Also, be aware of the double-arrow index finger cursor that appears over command words. Click and drag it to make quick sliding adjustments.

In the image above (at 5x7 inches) the text orientation is horizontal, the font family is Edwardian Script, font style is regular, font size is 94 points, the anti-aliasing method is Sharp, the text is left aligned, and the color is bright green. The text was not warped text, but it was rotated using the Edit>Transform>Rotate command. Notice that the angle of the text matches the tilt of the head and eyes.

On Holly's name, we added some layer styles by clicking on the Add a Layer Style icon (the "fx") in the layers palette. In this image, we used the Bevel and Emboss layer style, then added the Drop Shadow layer style. You have many choices of creating a text "look," and the order in which you apply effects is up to you. Analyze the image and choose a look that fits with it. After you have worked with text for awhile you will find certain favorites and "looks."

Borders and Edges

Borders and edge effects can really enhance the look of an image. The look can be a simple colored stroke within the image, or a brushed-edge look that goes well with any

Reduce the Fill

Another fun text effect can be achieved by reducing the fill setting (in the layers palette) for the text layer. This will make the text look as thought it is printed directly on elements in the image (on a wall, a sign, etc.). You must have a layer effect applied to the text for this to work; the layer effect then remains intact as the fill, or "paint," disappears.

Borders, in a variety of styles, can enhance the look of an image.

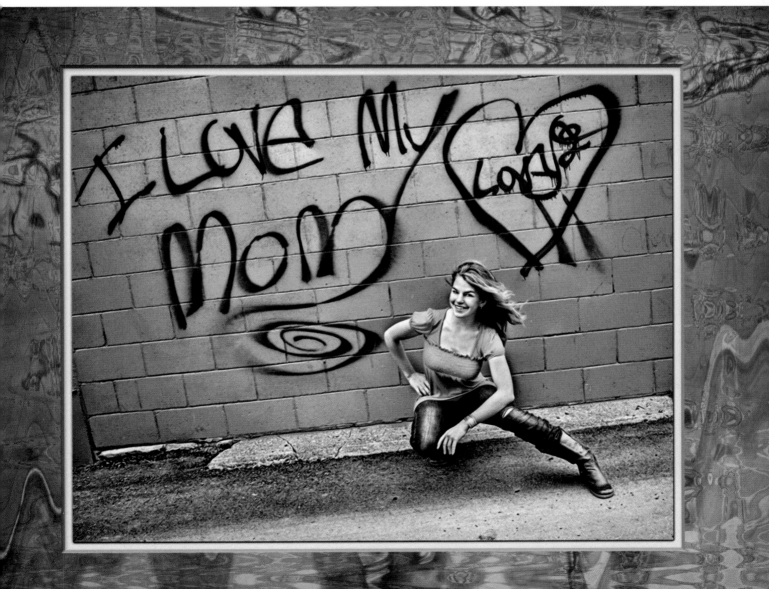

Image with a simple stroke border added.

Image with a brushed-edge border added.

painting and obvious handwork. It could be a dynamic blur effect that leads your eye into the image, or an artistic application that creates a unique mat, where the colors and texture are taken from the image itself and extended into the mat.

Simple Stroke Border. Open your image and use the Rectangle or Elliptical Marquee tool to select the part of your image around which the border will be created. Go to Layer>New>Layer Via Copy to put your selection on its own layer. With this new layer active (highlighted in the layers palette), click on the Add a Layer Style icon at the bottom of the layers palette and choose Stroke. In the dialog box that appears, choose: the size (usually 6 pixels or larger); the position (choose Inside for more defined corners); the blend mode (Normal); the opacity (100 percent), and the color (select a color from the image). If you like, you can also add a variety of other layer effects (Drop Shadow, Glow, Bevel & Emboss, etc.). Then click OK.

Brushed-Edge Border. This effect requires some work be done by hand. First, make a new background by going to File>New. This must be larger than your image (the exact settings will depend on the size and resolution of your image file). Click and drag your image onto the new white background. Click on the Add a Layer Mask icon at the bottom of the layers palette. Choose a Spatter Brush, found in the Brush Presets for the Brush tool. Set the blend mode to Normal and the opacity at 70–80 percent. Brushing the edges of the images at an angle gives a dynamic sense of direction to the edge. You may want to apply the Bevel and Emboss layer style to give the edge more dimension.

Zoom-Blur Border. To create this border effect, make a background copy of your image by dragging it down to the Create a New Layer icon at the bottom of the layers palette. Next, go to Select>All and Edit>Free Transform. Hold both the Shift key and the Alt/Opt key while drag-

ging the upper left corner of the image down. Doing this will automatically center your image on your background image. Hit Enter, then Ctrl/Cmd+D to deselect. At this point, working on the bottom layer, you can darken the background by going to Image>Adjustments>Curves and pulling down on the center of the diagonal line in the RGB composite channel. To add the Zoom Blur effect (again, make sure you are working on the bottom layer), go to Filter>Blur>Radial Blur. Choose Zoom Blur and set the Amount slider at 60–80. Set the Quality to Good. Hit OK.

Next, for more effects, click on the top layer and add a layer style by clicking on the Add a Layer Style icon at the bottom of the layers palette; choose Stroke. Pick a color from the image for this line, choose a size, and set the position to Inside (which gives defined corners). In the same dialog box, click on Outer Glow. Set the blend mode to Normal, choose a dark color, and adjust the Size slider until you see darkness around the entire image. This will give a three-dimensional look to the zoom-blur border.

AutoMatting Software. Go to www.imagetrends inc.com to download a trial copy of AutoMatting (or use the coupon code PHOTOBYJD for purchase). Open your image and rotate it to a horizontal position for an all-around border, then save it to a folder. Double click on the AutoMatting icon. Click the Add button and go to Look In: (location of your image). Click on the image and then hit Open. Then, click the Process Images button. When Processing Complete shows, click OK. A new folder will have been made and your image with the AutoMatting can be found there. You may want to add 15 to 20 points of Saturation (go to Image>Adjustments>Hue/Saturation) to give just a little more color overall.

Creative Composites

One new product line added an average of $150 to the seniors' orders when we introduced it several years ago: custom-designed, senior composite images. These images were so successful, in fact, that the following year we had

Image with a zoom-blur border added.

Image with an AutoMatting border added.

"If you're lucky enough to find a guy with a lot of heart, he's never going to come off the field second."
Vince Lombardi

to limit the offer to one per order—and no more than seven images in the composite. These composites were not the traditional cut-and-paste, fill-in-the boxes composites; each composite was—and is—unique. A single image serves as the background, then images are blended together over it and unique fonts and special borders are designed using the images themselves. The minimum size for a composite is an 8x10-inch print, but most are ordered as 16x20-inch prints. The senior pays a creation fee depending on the number of incorporated images plus the cost of the print and mounting. A smaller 8x10-inch copy is made of every composite and placed in a large display album in the sales room. They are their own selling devices.

Creating composites is definitely complex; like cooking an elaborate meal, it rarely follows a precise step-by-step plan. We always seem to need to add a little extra spice here and there to get the taste just right. All of the following steps, however, are necessary to complete a truly professional-quality composite.

Plan. Careful planning can mean the difference between a great composite portrait and a haphazard collage of pictures. Knowing a composite is in your client's mind prior to their session is important, so be sure to ask during your pre-session consultation. Aim for some type of theme for the composite (sports, music, fashion, etc.) rather than just a collection of unrelated images. If possible, photographing your subject against a plain background, with consistent lighting, will save you work later. Pose the subject in a variety of poses in different directions to help the composition of the composite. Composites with less than eight images are usually easiest to lay out with an odd number of images. Begin with one dominant, primary image in a compositionally strong position, then add other smaller images.

Prepare the Images. You should either offer composites as an "artist's creation" or have the composite artist help the client choose the images that will be included. Once selected, retouch and enhance the images, keeping in mind they should be consistent in terms of their color balance, contrast, sharpness, etc. Crop the images depending upon whether they are to be blended in the composite or presented in a preset shape.

BELOW AND FACING PAGE—*Custom composites are incredibly popular among high school seniors.*

ABOVE AND FACING PAGE—*Planning a creativity come together to produce exciting composites.*

Build a Background. You have several choices to create a base layer for the composite:

1. Use an existing image (with or without special enhancements).
2. Use an existing image with an extreme effect (blurs, color changes, filters, etc.) to create a new artistic image.
3. Create a new background from scratch with art tools (brushes, fills, etc.) or rendered with filters (clouds, lighting effects, overlay textures, etc.).
4. Use all or some of the above.

As you create, keep in mind the size of the resulting composite; whether you need a high-, medium-, or low-key background; and what colors will be the most complimentary with the included images.

Add Images. Begin adding images to the background. Convert image layers to Smart Objects to limit loss of image quality during resizing. Use layer masks, layer blend modes, the History Brush, and layer styles to blend and frame the images.

Get Creative! Add overlay textures and colors. Run filters. Add text and borders (covered earlier in this chapter). Lower the opacity of layers to make them look more transparent. Make the composite a true art piece.

What Lies Ahead

Take one look in the yellow pages and you can quickly determine that there is an overpopulation of photographers competing for their portion of the area's photographic business. Pick up any photography magazine and you'll read articles echoing the same sentiment. In this age of inexpensive 10-megapixel cameras, everyone—whether qualified of not—has become a "professional" photographer. Is this the end of true professional photography? Will we become another hand-set type printer? Another typewriter repair service?

Challenges of the Past

Let's take a look back in history. Over the decades, we've faced numerous threats to our family business.

Whatever technology throws your way, you have to keep producing top-notch images.

They made something called film that anyone could load. ("With no more glass plates and no more emulsions to mix, everyone will become a photographer and we'll be out of business!") But you know what? We're still here. We're still in business.

Then came the lighting advances. ("With those new-fangled, extra-brilliant photofloods, it's just like turning on a lamp in the parlor. Now everyone will become a photographer and we'll be out of business!") Guess what? We're still here!

Things became more portable. ("Whoever thought of putting bright-burning magnesium in a light bulb? It's so portable, you only need a battery to set it off. You can light your portraits anywhere with that new high-speed ASA 25 film. If you change a light bulb you can become a photographer! We'll be out of business!") Guess what? We're still here!

Things even got cheaper. ("Now they put some gases in a light bulb and pass a high voltage current through it and it gives off enough light to light the subject and stop the action. You can use the same bulb over and over again. Now anyone can afford to become a photographer! We'll be out of business!") Guess what? We're still here!

Do you see a trend? Does this bit of history sound like what's happening today with the advent of digital? Does this advance really represent the beginning of the end?

Why Did We Survive?

Why *didn't* our business fall victim to all the predictions? We accepted change as inevitable and utilized the new technology to stay in front of the competition. We also spent (and continue to spend) equal time analyzing our marketing programs. There will always be hobbyists and wannabe photographers in the market, but professionals who strive to grow, change, and provide top-notch products can still build thriving businesses.

An analogy can be made to the food industry. Sometimes, people want cheap, quick food. In that case, the fast food industry satisfies a need. However, when people want

to enjoy the ambience and quality of a fine meal, they are willing to spend many times the cost of fast food. Both satisfy hunger, but the fine restaurant satisfies a need for the finer things in life. It's the same in photography: sometimes a snapshot will suffice; other times, nothing but the best, professional-quality portraits will be good enough. And when that's what people want, they are willing to pay for it.

Planning for the Future

Show Them the Difference. It's up to you, as a professional, to let potential clients know that this is what you a providing—like a gourmet meal, let them see what a true professional can create. Display samples of your work so the public can see for themselves the difference between a truly professional portrait and that of the weekend wannabe.

Promote the Experience. Have you heard about the new slow-food restaurants? A group of fine restaurants in Madison, WI, have joined together to promote the quality of the experience of fine dining as well as the gourmet food. This bucks the trends promoted by the fast-food industry. At slow-food restaurants, food is served in courses over a period of up to three hours. This gives diners time to appreciate the décor, smell the aroma of the wine, and enjoy some in-depth conversation. Is it time for professional photographers to establish studios that feature "slow photography"? It's something to consider.

Spend time creating a senior experience only you can create. In our situation, we purchased an old farm and turned it into a working tree farm and outdoor photo-

graphic experience area. There, we can invite the client's family to ride the trails with us in a wagon. We can even photograph the high school senior's session on his ATV or dirt bike. All of this creates word-of-mouth advertising—the best there is.

Make it Easy. Here's another culinary analogy: my wife can prepare a meal and bake a pie that are as good as anything served by a fine restaurant. However, she doesn't have the time (or the desire) to do this kind of work for

Clients come to you for the experience of working with you, so give them a reason to spend a large amount of money at your studio.

every meal. We used to grow vegetables in our garden, then can them for use over the winter; now, we tend to purchase frozen vegetables. Similarly, the public can do some of the same things photographically that a professional photographer does. However, this doesn't mean the hobbyist will compete just because he can. Just like us, the public wants convenience!

The studio of today must consider changing their schedule and style of doing business to make it more convenient for the public to use its services. A recent survey sponsored by PPA listed things like evening hours and Saturday hours a high on the list of customer requests. The chain stores and malls are doing this, why aren't more professional studios?

Don't Emphasize Price. Don't base your senior marketing on price comparison only. You'll lose everything. The chain stores plan to lose money just to get you into the store (and buy other merchandise on your visit). The weekenders have no overhead to cover, so any money above the cost of materials is pure profit to them.

Update Your Product Lines. Change what you have to sell annually, and don't just sell one or two product lines. We're all in the picture-selling business; *how* we deliver them is what separates the successful from the unsuccessful. Clients come to you for the experience of working with you, so give them a reason to spend a large amount of money at your studio. Let's just assume they'll be purchasing the finished images and frames—that's a given.

Now, present them with something they had not thought of before. (Again, it's just like a great restaurant: after the meal comes the dessert cart, full of treats you had not intended to get but can't pass by.) The web is loaded with new products, as is your color lab. Things like banners, memory books, locker prints, art prints, original composites, and personal playing cards—they can all boost your bottom line.

Each year come up with a "new" product just for high school seniors. Make it very exclusive—something hard to obtain—and the public will do anything to get their hands on it (think of the "Tickle Me Elmo" dolls!). Be the first to offer a product. We have found products like personal playing cards, memory books, personal banner prints, personal videos, and CDs were all big hits the first year. Soon, though, everyone else copied the idea and the demand decreased. For our studio, artistic portraits done with Snap Art software are all the rage this year. As the old saying goes, "If you're not the lead dog, the view never changes!"

Keep Your Eyes Open

The next great idea could be right under your nose. Study what the big advertising agencies are doing to sell clothes, cars, and trinkets to your clients. They spend millions on research, so learn from them. What television shows and magazines are popular with your potential client? MySpace is all the rage among high school students, so think of a way to use it for marketing to them. Rather than have seniors copy your images illegally, give them digital files (with your name on each one!) to put on their web space.

Don't Give Up!

As digital photography keeps getting more widely available at lower costs, Photoshop is being taught in the middle schools, and soccer moms strive to be "mama-razzi" (profit-optional professionals), here's our advice: don't you give up! Stay one step ahead of the wave, continue to further your photographic education, remember the rules of good lighting and posing, create an experience for every session, and *change!*

What appeals to teens is always changing, so make sure to update your product line every year.

Alien Skin Software (www.alienskin.com). Enhancement, art, and special-effect plug-ins for Photoshop (Blow Up, Exposure2, Snap Art, Splat, etc.).

Adobe (www.adobe.com). Image processing, retouching, enhancement, and web-design software.

Apollo Photo Imagizing (www.apollo-imagizing.com). Professional photo printing, products, and press printing.

Backgrounds Express (www.backgroundsexpress.com). Backgrounds and supplies.

Blossom Publishing (www.blossom-publishing.com). Brochure and card printing.

Calumet Photographic (www.calumetphoto.com). Photo hardware, software, supplies, used equipment, etc.

Canon USA (www.usa.canon.com). Digital camera and flash equipment.

Dell (www.dell.com). Computers and displays.

Denny Manufacturing (www.dennymfg.com). Backgrounds, props, and posing equipment.

Dynamic Designs (www.dynamicdesigns1.com). Soft custom backgrounds.

Image Trends, Inc. (www.imagetrendsinc.com). Imaging software and plug-ins.

Kodak Professional (www.kodak.com, www.asf.com). Printers, paper, software, education, support, and more.

Larson Enterprises (www.larson-ent.com). Soff Boxes, reflectors, lighting equipment, backgrounds, etc.

The Levin Co. (www.levinframes.com). Frames and Autoframe sales software.

LaCie (www.lacie.com). External hard drives, displays, and more.

LucisPro (www.lucisart.com). Artistic image enhancement plug-in for Photoshop. (Coupon code JDWA2422.)

Media Supply. Archival CDs, DVDs, envelopes, pens, etc. (Rep.: Joe Navalance: [800] 681-9214; mention this listing for discounts.)

National Association of Photoshop Professionals (NAPP) (www.photoshopuser.com). Conventions, discounts, magazine, etc. (Use J.D. Wacker as reference when applying for membership.)

PC Mall/Mac Mall. Hardware, software, supplies, etc. (NAPP Rep.: Kristine Lane: [800] 555-6255 ext. 5497.)

Pierce Company (www.thepierceco.com). Studio supplies and props.

PocketWizard (www.pocketwizard.com). Radio slaves.

Shooting Gallery Backgrounds (www.shooting-gallerybackgrounds.com). Backgrounds.

Stock20.com (www.stock20.com). Royalty-free music.

Tallyn's Pro Photo Supply (www.tallyns.com). Photo hardware, software, supplies, and image recovery.

Tap (www.tap-usa.com). Professional photo folios, folders, mounts, albums, boxes, etc.

Wacom (www.wacom.com). Pen tablets.

Index